Charleston

and the GOLDEN AGE OF Piracy

Christopher Byrd Downey

THE
History
PRESS

Published by The History Press
Charleston, SC 29403
www.historypress.net

Copyright © 2013 by Christopher Byrd Downey
All rights reserved

First published 2013

ISBN 978.1.5402.0807.1

Library of Congress CIP data applied for

In loving memory of Cousteau...this man's best friend.

Did they watch it, day after day—
The pirates—
The doomed gold arcs of their hours slip round the sun-dial tree?
In the house place of Garret Vanvelsin—
Charles Town, in the Province of South Carolina,
Seventeen-hundred-eighteen,
They were trying the pirates;
Men of Stede Bonnet's; shipmates of Vaughn and of Blackbeard;
Noisome things of the sea, vicious with spines, smeared with
abhorrent blood.
They had scooped them a netful and flung it into a corner.
This vile frutto di mare.
The pearly swell and the color of coral and amber drained out of them,
Turgid and lax they lay,
Hardly with wills to answer, only waiting the outcome,
The gasp in this cursed, foreign air,
The last alien strangle…

—from the poem "The Pirates," by Beatrice Ravenel, 1927

Contents

Preface

Among my favorite childhood memories are family trips from our home in Virginia's smallest city of Colonial Heights to the bustling urban sprawl of Virginia Beach. With the car packed full of beach blankets, umbrellas and half-inflated rafts, the nearly two-hour ride seemed like an eternity for a ten-year-old. Unlike the pristine, spacious beaches of the Outer Banks of neighboring North Carolina, Virginia Beach is a monument to concrete and commercialism. Interstates merge and converge as panicked drivers cut one another off as they frantically try to exit into Virginia Beach's wall of hotels and stores. Traffic is paralyzed on Atlantic Avenue as endless droves of tourists, overloaded with beach chairs and coolers, lumber through crosswalks toward public beach access signs. In the backseat of our family station wagon, I had no sense of being at the beach or that the edge of America was only a couple hundred feet away. Even the sun was blotted out by the curtain of high-rise hotels that separated Atlantic Avenue from the ocean. But then, quite suddenly, there would be a small, open space between a Ramada Inn and a Best Western, and there it would be—a momentary glimpse of infinity. For just one split second, I could see the surf break and then nothing but mile after mile of open ocean stretching into an empty horizon. And that was all it took. I was in love for the rest of my life.

For a ten-year-old with a newfound passion for the water, boats and just about anything that swam or floated, it was not long before I was playing pirate. On the Appomattox River that flowed near my house, I would pretend that the brown, water moccasin–infested river was the Spanish Main and my

leaky canoe was a pirate ship. I would launch imaginary attacks on oblivious fishermen casting for bass from their jonboats. My friends and I would bury jars of pennies and then draw elaborate maps that we would inevitably lose in the matter of a couple of days (for anyone interested, there is still at least five dollars in coins in a glass jar somewhere on an island off Fort Clifton).

As I grew older, I inevitably gave up on most of my childhood dreams, like my plans to pitch for the Atlanta Braves or to win the Tour de France six consecutive times (without doping). But I never totally let go of my dream of running off to sea to become a pirate. I still daydream of leaving it all behind—the house, the car, the job—and sailing away to adventures on blue, clear waters and deserted, sandy islands. Unfortunately, the demand for pirates in the twenty-first century is fairly limited, or as Jimmy Buffett phrases it in "A Pirate Looks at 40": "My occupational hazard being, my occupation's just not around."

When I started my pirate boat tour business (CaptainByrds.com), hauling sunburned tourists around Charleston Harbor, I rationalized that the time, energy and frustrations that a tour business required were all worthwhile because the ticket sales paid most of the bills for my boat. But the truth is that my pirate boat tour business, just like this book, isn't about profits. It is just an adult version of playing pirate. And sometimes during a tour, when a family of four from Ohio are not paying attention to my tales of Blackbeard and Stede Bonnet because they are busy pointing and screaming at a nearby surfacing dolphin, I still launch imaginary pirate attacks on unsuspecting boaters.

I hope this book gives the reader the chance to escape from his or her everyday life and play pirate for a while—with the beautiful and charming city of Charleston as a backdrop.

There are more people to thank for their help with this book than space allows, but there are a certain few to whom I would like to express my gratitude. Thank you to Mike Coker and the staff at the Old Exchange and Provost Dungeon, Alan Stello and the staff at the Powder Magazine, Eric Lavender of Charleston Pirate Tours, the North Carolina Department of Cultural Resources, the staff at the South Carolina Historical Society, the staff at the South Carolina Room at the Charleston County Library, the staff at the Charleston Library Society, the staff at the North Carolina Maritime Museum at Southport, Paula M. Sokoloski at Sign Design, Bill McIntosh at St. Phillip's Church (Charleston), Gian Paolo Porcu for his help with the pictures in this book, Kevin Duffus, the Charles Towne Few, Alice Stewart Grimsley at the Pink House Gallery and Lizzie Porcher White. I

extend a special debt of gratitude to my family. Also, thank you to Tina for your support and for putting up with me during the writing of this book. You make me a better writer and a better person.

Charleston was called Charles Town until the city's incorporation in 1783; however, for the ease of the reader, I have referred to the city as Charleston throughout the book. Unless otherwise noted, all images appear courtesy of the author's collection.

CHAPTER 1
A Golden Age Begins

July 1722—Captain Gwatkins walked in the early morning shade of Charleston's eastern wall. Although the sun was only just beginning to clear the horizon, the air was already heavy and humid, and the shadow cast by the deep brick wall offered the captain a small degree of relief. Stopping at a set of makeshift wooden steps wedged into the brick, he tested each plank with the weight of a single boot before slowly climbing to the top of the wall. Finding his balance atop the wall, Captain Gwatkins squinted as the morning sun and its reflected glare from the harbor filled his eyes and warmed his salt-worn face. Below, he could see the *Amy* tied up alongside Rhett's Wharf and his crew already making preparations for departure. The *Amy*'s freshly polished cannons gleamed in their carriages as the merchantman sat motionless in the slack tide.

Rather than passing his last night in Charleston inside his cramped quarters onboard the *Amy*, Captain Gwatkins had spent some of his meager earnings on a room in a boardinghouse on Bay Street. After a career at sea, Gwatkins had no real city or address that he could call home. But as the captain of the *Amy*, with a regular trading route that moved rice from Charleston to England and then household goods, wares and oftentimes passengers from England back to Charleston, the walled city and its friendly people had become as close to a home as Gwatkins had ever known.

Tired and his head aching from a long night of countless toasts with friends, Gwatkins had reluctantly woken early to catch the morning ebb tide. He could see the flags on the Half Moon Battery gently snapping in the westerly breeze

as a few uniformed militiamen began to mull around the Court of Guard. Beyond the Half Moon Battery, the morning silence was broken as cannon fire erupted from Granville Bastion at the southeast corner of the city wall. A flock of startled black terns scattered from the sand below and flew low over White Point. The Charleston citizenry were not nearly so skittish; they had become accustomed to the cannon fire, as the militia would regularly range its guns by firing across the empty harbor. Returning his attention to the *Amy*, Gwatkins could see the telltale sign of the start of the falling tide as the ship's wheel strained with the pressure of the water rushing against the rudder. Moving water now wrapped and streamed around the pilings of Rhett's Wharf. Gwatkins's eyes locked with those of his boatswain, who was singling up the lines that held the *Amy* alongside the wharf, and the two men shared a knowing nod. It was time to set sail for England.

Now pacing the *Amy*'s quarterdeck, Captain Gwatkins gave the order to let the stern line loose, and the ship spun gently on her spring line as the current pulled the *Amy* off the wharf. When the spring line was released, the bow turned, and the *Amy* steered south-southeast toward the mouth of the harbor. The experienced Captain Gwatkins knew that by sailing at the very start of the outgoing tide, there would still be enough water under keel to pass safely over the treacherous Charleston bar that sat just offshore.

In the lee of the city walls, the sails hung limp with only the current propelling the *Amy*. Passing beneath the flags fluttering on the Half Moon Battery, Captain Gwatkins ordered the *Amy*'s cannons fired as a salute. The seasoned crew cast their eyes toward Granville Bastion to make sure the militia had ceased ranging its cannons as they slipped past. Friendly waves and shouts were exchanged with the soldiers, and as the *Amy* cleared the city walls, her sails filled with the unbroken westerly wind. The merchantman fell off onto a broad reach toward Sullivan's Island's western tip and directly into the morning sun.

Hidden in the bright morning sun on the opposite side of Sullivan's Island, another vessel waited in the north channel. The sloop *Ranger* had crossed the bar the previous night on the moonlit floodtide. The *Ranger* carried ten cannons on her deck and eight swivel guns mounted on her railing. Much like Captain Gwatkins, the *Ranger*'s captain, George Lowther, had spent most of his life serving on merchant ships, achieving the rank of second mate. However, for the last year, George Lowther had been "on the account" and had been terrorizing merchant vessels from Barbados to New York. George Lowther was a pirate, and the *Ranger* had come to Charleston to prey on traffic coming in and out of the harbor.

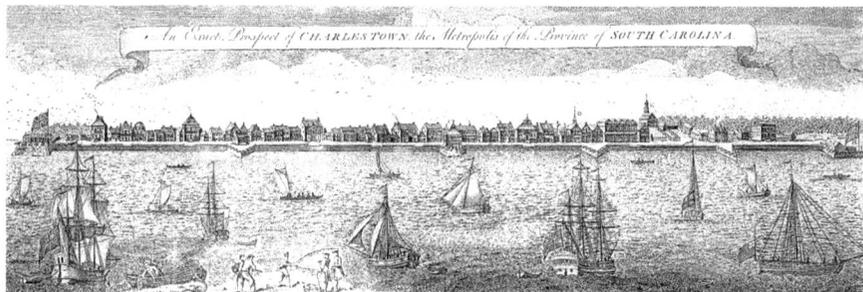

A 1739 drawing by Bishop Roberts of the busy Charleston waterfront. The Half Moon Battery and the Court of Guard building can be seen at the center. Granville Bastion is at the extreme left.

Little is known of George Lowther prior to 1721. In May of that year, he arrived at the Gambia River in West Africa onboard the Royal African Company's ship *Gambia Castle*. The *Gambia Castle* was carrying a garrison of soldiers under the command of Captain Massey to rendezvous with Colonel Whitney at a slave-trading fortress on James Island (today named Kunta Kinteh Island). The English fortress at James Island had been captured and ransacked several times in its history by both the Dutch and the French. It had most recently been destroyed by a pirate named Captain Howel Davis. The soldiers onboard the *Gambia Castle* had been sent to reestablish order and offer support to Colonel Whitney, who had been sent to assume the position of governor of James Island. However, it was not long after the *Gambia Castle*'s arrival that it became clear to George Lowther and many of the crew, as well as to Captain Massey and his soldiers, that their presence was not welcomed at James Island.

The merchants and slave traders on James Island had grown accustomed to governing themselves in the aftermath of Captain Davis's pirate attack, and they were not interested in relinquishing power to Colonel Whitney and his soldiers. The merchants conveyed their defiance by not supplying the food and provisions to Captain Massey's troops inside the fort, as required in the government charter held by would-be governor Colonel Whitney. To make matters worse, Colonel Whitney became gravely ill and was confined to his cabin onboard the *Gambia Castle* for weeks, rendering him unavailable to negotiate with the rebellious merchants as the soldiers' situation grew increasingly desperate. Morale of the crew on the *Gambia Castle* was also reaching a critically low point. The *Gambia Castle*'s Captain Russel, burdened with the sick Colonel Whitney onboard and the uncertain fate of the soldiers ashore, was unwilling to depart and sail back to England. Objections raised

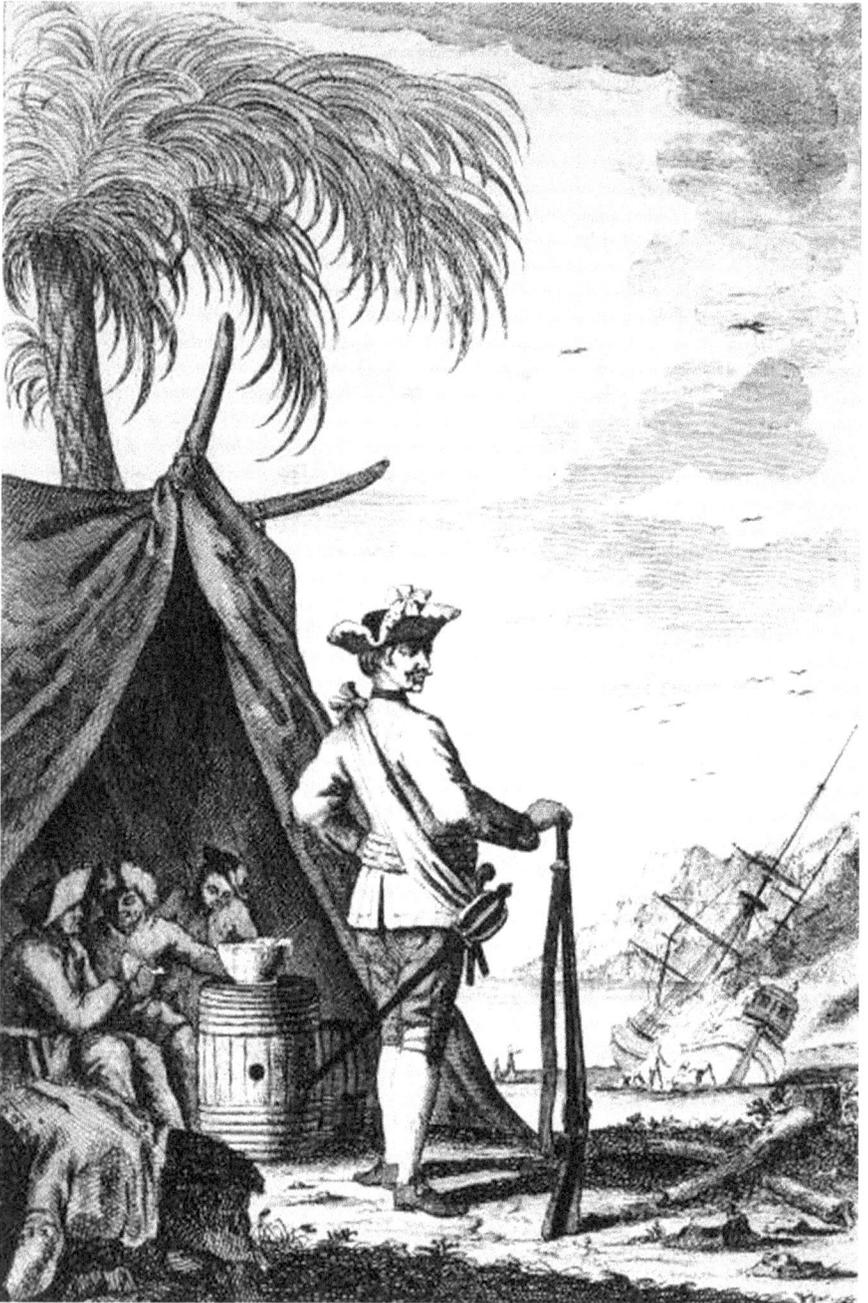

George Lowther.

by George Lowther on behalf of the crew were met with swift punishment by Captain Russel. Restless from weeks at anchor in the Gambia River and low on provisions, murmurs of mutiny spread amongst the crew.

Late one night, Captain Massey came onboard the *Gambia Castle* and partook of some drinks below deck with the seething George Lowther. Both men shared their sense of anger and frustration with their current situation. Lowther proposed a plan for Massey and his loyal soldiers to join the mutinous crew in forcibly taking the ship and returning to England. The scheming Lowther seems to have convinced the gullible Massey that they would be committing no real crime and would be warmly received in England as heroes who had simply extricated themselves from a futile situation. The truth was that George Lowther was planning to turn pirate.

Several nights later, Lowther and Massey put their plan into action. Massey and those soldiers loyal to his cause came aboard the *Gambia Castle*. Those among the crew who did not want to join the mutiny were landed ashore. The mutiny had an unceremonious and ominous start, as the *Gambia Castle* ran aground almost immediately after slipping her anchor line. The mutineers spent a long, anxious night waiting for the tide to lift their ship off the sand. The next morning, free from the river bottom, the crew set sail and stood for the open sea, exchanging cannon fire with other vessels in the river, including the *Martha* and the *Otter*.

Once clear of the coast and out of danger, Lowther assembled and addressed the crew and soldiers. Outlining his plan to turn pirate, he said, "It was the greatest folly imaginable, to think of returning to England, for what they had already done, could not be justified upon any pretence whatsoever, but would be looked upon, in the eye of the law, a capital offence." To the shock and horror of Captain Massey and most of his soldiers, Lowther suggested that the only option left was piracy and "to seek their fortunes upon the seas." The crew resoundingly agreed. The *Gambia Castle* was renamed the *Happy Delivery* and refitted as a pirate ship. George Lowther was voted captain, and a set of rules and code of conduct, called "articles," was drawn up and signed by the crew. Similar to the articles of many pirate crews of the period, the "Articles of Captain George Lowther and his Company" included a disability plan for those wounded in battle and a bonus for the first crew member to spy a prize:

> 1. *The Captain is to have two full Shares; the Master is to have one Share and a half; The Doctor, Mate, Gunner & Boastswain, one Share and a quarter.*

2. *He that shall be found Guilty of taking up any unlawful Weapon on Board the Privateer, or any Prize, by us taken, so as to strike or abuse one another, in any regard, shall suffer what Punishment the Captain and Majority of the Company shall think fit.*

3. *He that shall be found Guilty of Cowardize, in the Time of Engagement, shall suffer what Punishment the Captain and Majority shall think fit.*

4. *If any Gold, Jewels, Silver, &c. be found on Board of any Prize or Prizes, to the value of a Piece of Eight; & the Finder do not deliver it to the Quarter-Master, in the Space of 24 Hours, shall suffer what Punishment the Captain and Majority shall think fit.*

5. *He that is found Guilty of Gaming, or Defrauding another to the Value of a Shilling, shall suffer what Punishment the Captain and Majority of the Company shall think fit.*

6. *He that shall have the Misfortune to lose a Limb, in time of Engagement, shall have the sum of one hundred and fifty Pounds Sterling, and remain with the Company as long as he shall think fit.*

7. *Good Quarters be given when called for.*

8. *He that sees a Sail first, shall have the best Pistol, or Small-Arm, on Board her.*

A few weeks after departing from the Gambia River, the *Happy Delivery* had crossed the Atlantic and was off the coast of Barbados, where the new pirates captured their first prize, the *Charles* from Boston. Piracy came easily to Lowther, and a near yearlong orgy of attacks throughout the Caribbean followed. In the autumn of 1721, near the Cayman Islands, Lowther joined forces with the infamous and ultraviolent Edward Low, who would earn a fearsome reputation for his cruelty toward captives, including cutting off the ears and noses of those who resisted. On January 10, 1722, Lowther and Low came upon the merchantman *Greyhound* from Boston. The *Greyhound*'s Captain Benjamin Edwards ordered his gunners to open fire on the *Happy Delivery*. A lengthy running engagement ensued in which several broadsides were exchanged, but Captain Edwards found the pirates to be too strong and struck his colors and surrendered. Incited by the maniacal Edward Low, the pirates boarded the *Greyhound*, "whipped, beat and cut the men in a cruel manner" and then set the merchant vessel on fire.

Uncomfortable and guilt-ridden with his new role as a pirate, Captain Massey requested that he be allowed to redeem himself by leading his soldiers in an assault on an island settlement belonging to England's traditional enemy of France. Massey seemed to believe that whatever sins he had committed

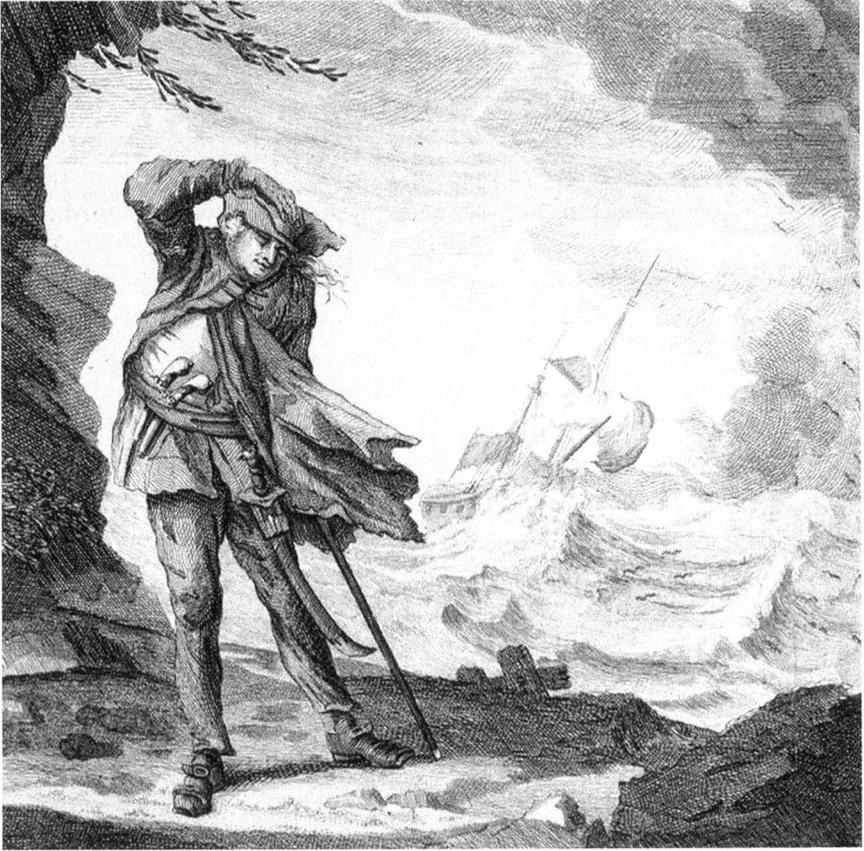

Edward Low.

could be forgiven through a military victory won in the name of England. But the pirates quickly overruled any plans for a land assault. When a sloop from Jamaica bound for England was captured a few days later, Massey and his guilty conscience boarded the prize and sailed for Jamaica to surrender himself and plead his case to Jamaica's governor, Nicholas Laws. Upon his arrival, Massey told Governor Laws his story and confessed his part in the mutiny in the Gambia River but explained that "'twas to save so many of His Majesty's subjects from perishing, and that his design was to return to England; but Lowther conspiring with the great part of the company, went a-pirating with the ship; and that he had taken this opportunity to leave him, and surrender himself and vessel to his excellency." Governor Laws took pity on the wayward Massey and promised his favor in any future trial.

Massey was given liberty and was even allowed to sail on the sloop *Happy* in a government-sponsored expedition to hunt for Lowther in the waters around Jamaica. The expedition proved unsuccessful, and when Massey returned to Jamaica, Governor Laws wrote a letter of endorsement and financed passage for Massey to return to England to stand trial.

Upon his arrival in England, a vice-admiralty court was convened, and Massey's trial began in London at the Old Bailey on July 5, 1723. The prosecution had assembled several witnesses, including the *Gambia Castle*'s Captain Russel, to testify against Massey. His guilt was never in doubt. Even Massey himself seemed to accept his fate, and rather than present a defense or challenge the prosecution, he used his time to simply entertain the court with a detailed recounting of his adventures over the previous two years. Massey made only one request to the court—that he face a firing squad as fitted the honor of an army officer rather than be hanged as a pirate. His request was denied, and three weeks after his trial, Captain Massey was hanged at Execution Dock at Wapping on the Thames River.

George Lowther had continued his pirating campaign through the Caribbean after Massey's desertion to Jamaica. Sailing into the Bay of Honduras, Lowther and Low captured several more merchant vessels, and by the time the pirates dropped anchor in the shelter of Port Mayo to perform repairs and careen hulls, Lowther had grown his pirate fleet to four ships and now referred to himself as Admiral Lowther. The admiral and his crews set up camp on the beach at Port Mayo and were carousing under the shade of sail canvas when a large group of natives emerged from the jungle and attacked the unprepared, rum-soaked pirates. Those who were not killed ran for their lives and scrambled onto the nearest vessel. Most of the pirates, including Lowther and Low, escaped on the recently captured eighteen-gun sloop *Ranger*. The *Happy Delivery* did not survive the attack. Staring back toward the beach from the deck of the *Ranger*, Lowther and his crew watched as the natives burned their flagship to the waterline.

Lowther set a course for the east coast of North America and its busy port cities. On the long voyage, the pirates grew quarrelsome—mostly over who bore responsibility for the debacle on the beach at Port Mayo. Even the capture of the brigantine *Rebecca*, bound for Boston from St. Christopher's (present day St. Kitts), did little to quell the divisive spirit that now pervaded the crew. A disgruntled Edward Low decided to part ways with Lowther. With forty-four loyal crew members, Low took command of the *Rebecca* and bid farewell to Lowther off the Delaware capes in May 1722. Lowther continued north with the *Ranger* to the waters off New York and captured

several fishing vessels and a small New England ship from which the pirates pilfered only a small amount of rum, sugar and pepper, as well as six slaves. Anxious to capture a lucrative prize and regain the faith and respect of his dwindling crew, Lowther set his sights to the south and the busy port city of Charleston. The *Ranger* appeared outside the harbor in early July—directly in the path of Captain Gwatkins and the *Amy*.

As the *Amy* cleared the western tip of Sullivan's Island, Captain Gwatkins steered to the east into the narrow channel that ran parallel and precariously close to the beach. The crew eased the sheets, as the wind now blew from directly astern. The boatswain, who was still coiling the mooring lines near the forecastle, was the first to notice the strange sloop positioned broadside to the channel and drifting directly ahead of the *Amy*. Just as the boatswain called out to Captain Gwatkins at the helm, the pirates ran out their cannons and hauled their black flag to the *Ranger*'s masthead. After more than a year as a pirate, George Lowther had become a student of psychological warfare. He knew that fear and intimidation were as effective tools as the gun and the sword. Like an angry dog bearing his teeth, the sight of the black flag and readied cannons had been persuasive enough to convince the vast majority of Lowther's prizes to surrender without the need of a single shot being fired. But Captain Gwatkins was determined not to relinquish the *Amy* or her cargo without a fight.

Captain Gwatkins ordered his crew to man the portside cannons that rested, still uncovered, in their carriages from their earlier salute at the Half Moon Battery. Quickly loaded and primed, the *Amy*'s guns were run out as Gwatkins turned hard to starboard and crossed to the far side of the channel, presenting the portside cannons broadside to the *Ranger*. Caught by surprise, the pirates had no time to maneuver as the *Amy*'s guns erupted. Hotshot ripped through bulwarks and bodies. Dead and dying pirates collapsed at their stations as rigging crashed to the deck. Men with splinters of wood lodged in their bodies screamed out and ran for cover, abandoning their gun stations. As the *Amy* reached the far edge of the channel, Captain Gwatkins steered back downwind and directly toward the *Ranger*. The *Amy*'s bow chasers, mounted on the forward railing, fired deadly grapeshot into the midst of the confused pirates. The *Ranger*'s panicked helmsman steered away from the *Amy* and toward the beach. The *Ranger* suddenly lurched and heeled violently to the starboard side. Limp, lifeless bodies rolled across the deck and collected against the starboard rail. The *Ranger* had run aground. Lowther ordered the longboat lowered into the water, but many of the pirates had already jumped over the side and were swimming for the beach.

Those who did join Lowther in the longboat rode the breakers onto the beach and scrambled for cover in the dunes.

Cheers from the *Amy*'s adrenaline-fueled crew were abruptly curtailed by Captain Gwatkins's order to heave to and drop anchor. Confused and anxious glances were exchanged among the crew as Gwatkins turned and stared back toward Charleston. He knew that the *Ranger* could be refloated, and once the *Amy* had departed, the pirates would most likely ambush the next unsuspecting merchantman coming out of the harbor. Or even worse, the pirates might sail into the harbor and attack the city. Determined to protect his friends and adopted home, Gwatkins turned to the crew and gave the order to lower the longboat; they would set the *Ranger* on fire.

Straining at their oars against wind and tide, the small group slowly rowed the *Amy*'s longboat across the channel. Standing in the bow, Captain Gwatkins shaded his eyes with cupped hands and watched the deck of the *Ranger* for any movement, but none could be seen on the eerily quiet pirate ship. Nor could any pirates be seen on the beach—only their abandoned longboat floating in the surf. The boatswain manning the oar closest to Captain Gwatkins peered nervously over his shoulder toward the beach. He saw the flash and billow of smoke come from the tall grass in the dunes before the sound of musket fire reached his ear. Captain Gwatkins's body twisted and crashed backward into the boat, his dead eyes still wide open and staring blankly into the empty morning sky. A hole in his forehead leaked blood into the bottom of the boat.

The *Amy*'s panicked longboat crew abandoned the plan to set fire to the *Ranger* and quickly returned to the safety of their ship. Dispirited by the loss of their captain, they weighed anchor and continued on their voyage to England. With the *Amy*'s departure, the still-stunned pirates stumbled from the dunes and regrouped on the beach. Preparations were made to pull the *Ranger* off the sand. An anchor was lowered into the longboat, rowed out and dropped in the channel. The crew labored and heaved at the capstan and wound the taut anchor line around the drum, slowly towing the *Ranger* off the sand and into deeper water. Now afloat and able to set sail, a meeting was held on the deck, where the demoralized pirates voted to retreat and find an anchorage in North Carolina to make repairs and allow the wounded time to recover.

When news of the action between the *Amy* and *Ranger* outside their harbor reached the Charleston citizenry, there was no alarm raised. Panic and fear did not grip the city. By the time of Lowther's arrival in 1722, Charleston had already suffered under pirate blockades, its citizens had fought the

rogues in sea battles and its courts had tried and hanged dozens of pirates. For more than a decade, Charleston had been at the center of the period that historians would come to call the "Golden Age of Piracy."

Piracy has existed for as long as man has moved goods on the water. In 75 BC, a young Julius Caesar was captured by pirates in the Aegean Sea. Held for ransom for eighty-four days, Caesar integrated himself into the pirates' community, even writing and performing plays with his captors. However, throughout his detainment, Caesar obstinately promised the pirates that upon his release he would have them all captured and crucified. Unaware of his high station and influence, the pirates did not take seriously Caesar's threats and posturing. When Caesar was released to Rome, true to his word, he immediately commissioned a naval expedition to capture the pirates. But as a gesture of mercy, Caesar had their throats cut rather than make them suffer the slow death of crucifixion.

More than two thousand years later, pirates are still active in modern times. As of the time of the writing of this book, the International Chamber of Commerce's International Maritime Bureau (IMB) recorded 297 pirate attacks worldwide in 2012, down from 439 attacks in 2011. The IMB's report cited that 585 persons were taken hostage by pirates in 2012, compared to 802 the previous year. This downturn was due in large part to the coordination of international naval operations and the use of armed security escorts in the world's most dangerous regions, including the coast of Somalia, the Gulf of Aden, Malacca Straits and the emerging pirate hotbed of the Gulf of Guinea near Nigeria.

But when most people think of pirates, the classic images of buried treasure, rum, peg legs and parrots come to mind. Our daydreams drift to the pirates of classic literature, like Long John Silver from Robert Louis Stevenson's *Treasure Island* or the trickster Jack Sparrow from Disney's *Pirates of the Caribbean* movies. These pirates derive from a fairly small period of history that encompassed roughly the first quarter of the eighteenth century. Earning the moniker the "Golden Age of Piracy," the period saw as many as five thousand men go "on the account" (a popular contemporary expression for turning pirate). A time of extreme violence, Marcus Rediker, in his book *Between the Devil and the Deep Blue Sea*, estimates that "no fewer than 400, and

probably 500–600 Anglo-American pirates were executed between 1716–1726." It would be the coinciding of two catastrophic events that would give birth to this "golden age."

Charles II of Spain, born in 1661, was the only surviving child of his father, King Phillip IV. Deformed in both body and mind, Charles was the product of generations of inbreeding by the Hapsburg royal family in an effort to maintain their royal bloodline. He was eight years old before he learned to walk, and facial deformities made his speech barely understandable. Insanity ran in Charles's family. His great-great grandmother, Queen Joanna of Castile, became insane early in life and was known as "Joanna the Mad." Charles's madness was blamed on sorcery, and he earned the nickname "the Hexed." The royal court even held an exorcism to drive out the demons that paralyzed his mind. Described as "short, lame, epileptic, senile...and always on the verge of death," Charles ascended to the throne of Spain upon his father's death in 1665. King Charles II married twice during his reign but was unable—or unwilling—to produce an heir. When he died at thirty-nine years of age on November 1, 1700, Charles's last will named Philip, Duke of Anjou and grandson of King Louis XIV of France, as the heir to the Spanish throne. For England and its allies, the

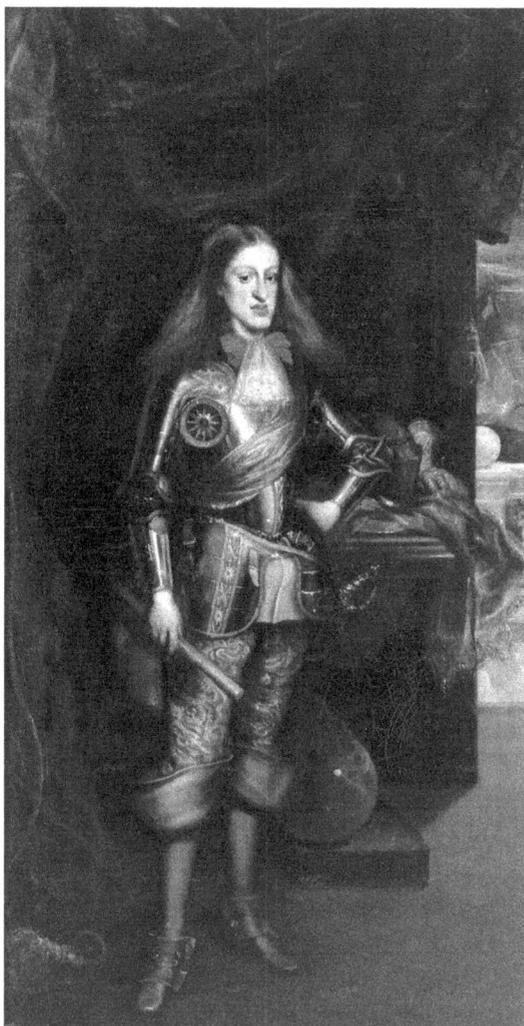

King Charles II of Spain.

consolidation of the thrones of France and Spain (both England's traditional enemies) was an unacceptable proposition. The global war that this dispute sparked came to be called the War of Spanish Succession. The portion of the war fought in the Americas and Caribbean was referred to as Queen Anne's War, in honor of the reigning monarch of England.

None of the nations involved in this war were capable of raising and outfitting navies large enough to fight a conflict of such a huge scale. All sides turned to the practice of privateering—essentially legalized piracy. Private ship owners could apply to their governments for letters of marque, which authorized the attacking and plundering of vessels from enemy nations. Sailors signed up in droves to serve on privateer ships, not out of a sense of patriotism but for the promise of prize money. Rather than payment through a salary, the crew of a privateer was given shares of treasure and goods taken from captured prizes. A sailor on a privateer might earn more from the capture of one enemy vessel than he would receive in a year's service in the navy.

In 1713, an uneasy peace was reached with the signing of the Treaty of Utrecht. The treaty recognized Philip as the king of Spain but dictated that he renounce any claim to the throne of France. The European superpowers had settled their differences, even if only temporarily, but in the Caribbean and along the eastern seaboard of America, a new storm was forming. Edmund Dummer, who developed the first mail service between England and islands in the Caribbean, prophetically wrote in 1702, "It is the opinion of everyone that this cursed trade [privateering] will breed so many pirates that when peace comes, we shall be in more danger from them than we are now from the enemy." Thousands of sailors who had served on privateer vessels during the war now found themselves unemployed and restless. The leap from privateer to pirate was only one of documentation, and a natural disaster was about to ignite the piracy powder keg.

Since the start of the war, the threat of enemy privateers had made Spain fearful of moving gold, silver and other treasures from its colonies in the Caribbean and Mexico to Spain. With its treasury depleted by more than a decade of war, Spain sent orders for one of the largest treasure fleets ever assembled to set sail from Cuba to Cadiz. In July 1715, eleven heavily laden galleons set sail from Havana. Less than a week into the voyage, as the galleons sailed along the southeastern coast of Florida, a massive hurricane bore down on the treasure fleet. The strong easterly winds forced all but the lead galleon onto the near shore reefs. Ship hulls were ripped open on the sharp coral. When the storm subsided, the wreckage of ten galleons and

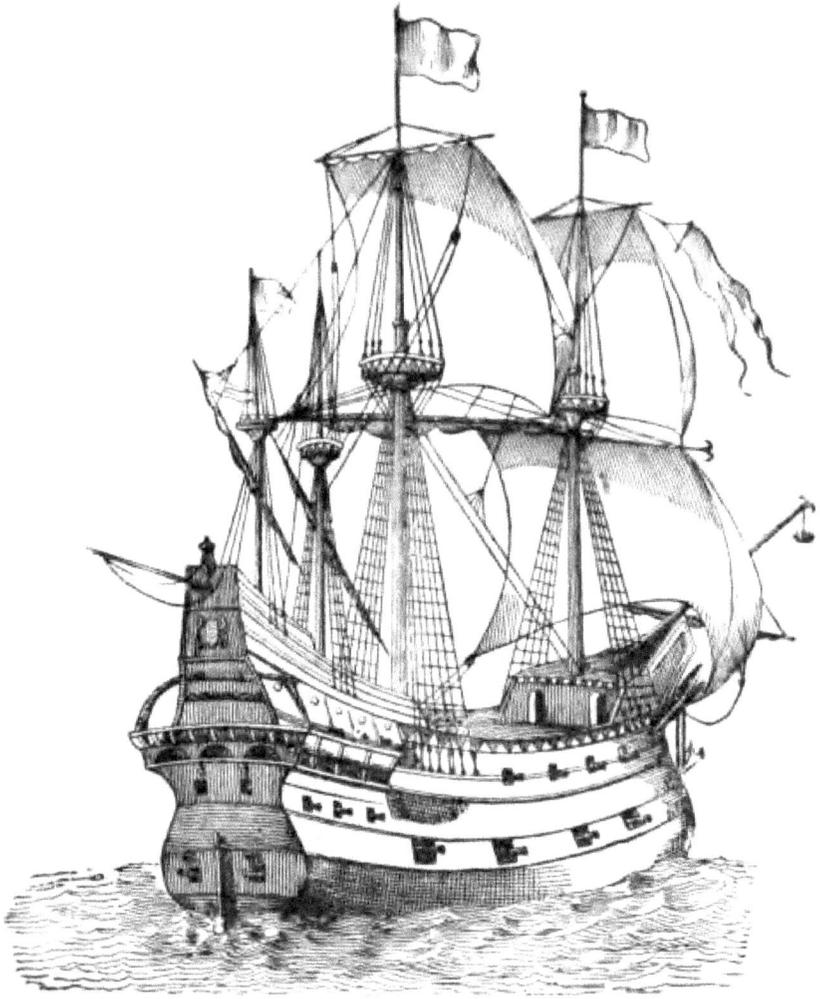

A Spanish galleon.

the bodies of more than one thousand sailors were strewn over forty miles of reef. A fortune in Spanish gold and silver coins settled on the sea floor in the shallow, clear water. As many as one thousand survivors swam and crawled their way onto the beach. A makeshift fort was built on the beach, and salvage operations began almost immediately as the survivors began diving the wrecks to recover the lost treasure.

The news of the Spanish wrecks spread like lightning throughout the Caribbean and America. Like sharks sensing blood in the water, the out-of-

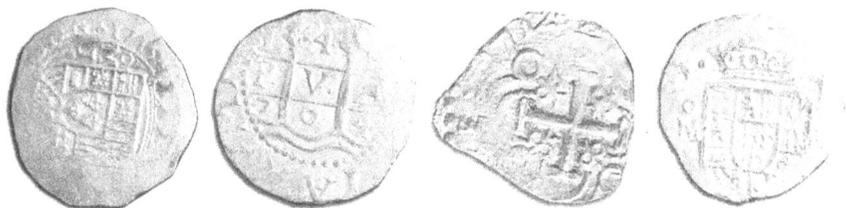

Gold coins recovered from the 1715 Spanish galleon wrecks off the Florida coast. *From left to right*: eight escudos (doubloon), four escudos, two escudos and one escudo. *Photo courtesy of Anthony E. Bakker.*

work former privateers languishing in port were drawn to the promise of an easy financial reward at the expense of their old Spanish enemy. Vessels from as far north as Boston were fitted out to go "a-wrecking" off the Florida coast. Among the first to arrive at the wrecks was a former privateer named Henry Jennings. In an act of outright piracy, Jennings and his crew decided to mount an attack on the Spanish fort, which held already recovered treasure. The Spanish defenders were so overwhelmed by the sheer number and boldness of Jennings and his men that they surrendered without a shot being fired. Soon afterward, the waters were swarming with "wreckers" anxious to make their fortune. The Spanish deployed warships from its nearby colonies to chase off the unwelcome visitors, driving most of the wreckers to seek refuge in the nearest English-speaking port at Nassau, Bahamas.

Named in honor of William II, from the Dutch house of Orange-Nassau, who would later become King William III of England, Nassau was located on the island of New Providence. The Bahamas consisted of over seven hundred islands, but by the start of the eighteenth century, New Providence was one of only a few populated islands, with Nassau as its only real town. Prior to the arrival of the wreckers, there were fewer than one hundred full-time residents. Any previous population growth had been thwarted by repeated French and Spanish raids, causing Nassau's settlers to retreat to Jamaica. With the resulting weak and unstable economy of the island, Nassau had been a pirate haven for decades. Authorities were willing to turn a blind eye to visiting pirates selling cheap, smuggled goods in their fledgling colony. In 1696, Governor Nicholas Trott sealed Nassau's reputation as pirate-friendly when the infamous Henry Avery, with over one hundred pirates, arrived in Nassau Harbor on the treasure-laden *Fancy*. Avery openly and publicly bribed Trott to allow him and his fellow pirates to dispose of their ill-gotten goods among the struggling inhabitants of Nassau.

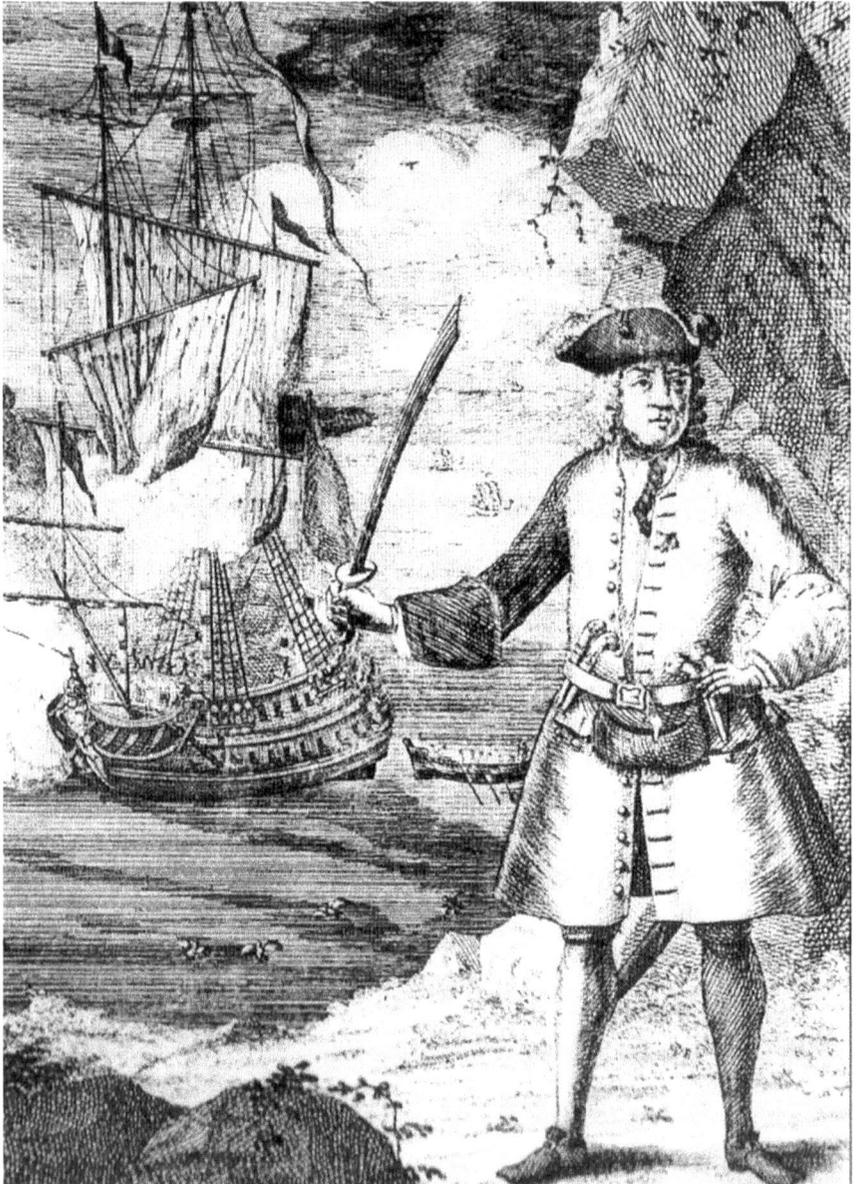

Henry Avery.

When the wreckers operating out of Nassau had fished the Spanish wrecks dry, outright piracy against merchant vessels began. Nassau was strategically located adjacent to the busy shipping lanes of the Florida Straits, the eighteenth-century ocean superhighway for the movement of goods between

the ports of Europe, the Caribbean and America. The English pirates based in Nassau initially confined their attacks to those vessels belonging to old enemies, like Spain and France, but it wasn't long before greed trumped patriotism and ships of all nations became fair game. Nassau became a "pirate nest," and the Admiralty Office in London was flooded with letters of complaint and requests for protection. In 1717, George Logan, speaker of the House of Assembly in Charleston, wrote to London in reference to the planned departure of the warship *Shoreham* from Charleston Harbor:

> *By reason of the design the Pirates of the Bahama Islands (and who are numerous) have to attack…we cannot suppose, that any such persons have a regard to, or make any difference or distinction, between the people of any nation whatsoever: we ought to provide for the safety and defence of the Inhabitants of this Province. This house humbly conceives; that it would be requisite…his Majesty Ship* Shoreham *to stay some time longer here with said Ship and that it would in some measure deter the Pirates from coming here.*

Virginia's lieutenant governor, Alexander Spotswood, wrote in the same year that the pirates in Nassau could "prove dangerous to British commerce if not timely suppressed."

Letters were received in London in regards not just to piracy's hazard to commerce but also to its threat to Great Britain's political stability. The fragile nature of the line of succession to Britain's throne was making the menace of the growing number of pirates in Nassau even more broad reaching than previously imagined.

King James II was not popular among England's Protestant and political elite when he ascended to the throne upon the death of his brother, King Charles II, in 1685. Although a practicing Catholic, King James II was considered to be a limited threat since his daughter and successor, Mary, was a Protestant. However, when James's second marriage produced a potential male and Catholic heir, James Francis Edward Stuart, Protestant authorities encouraged Mary's husband, William, to invade England and "save the Protestant religion." In the events that would come to be known as the Glorious Revolution of 1688, King James II fled to France, and Parliament passed the Bill of Rights of 1689, which recognized Mary and her husband, William, as joint rulers. King William III and Queen Mary's heirs, and the heirs of Mary's sister, Anne, were recognized as the legitimate successors to England's throne.

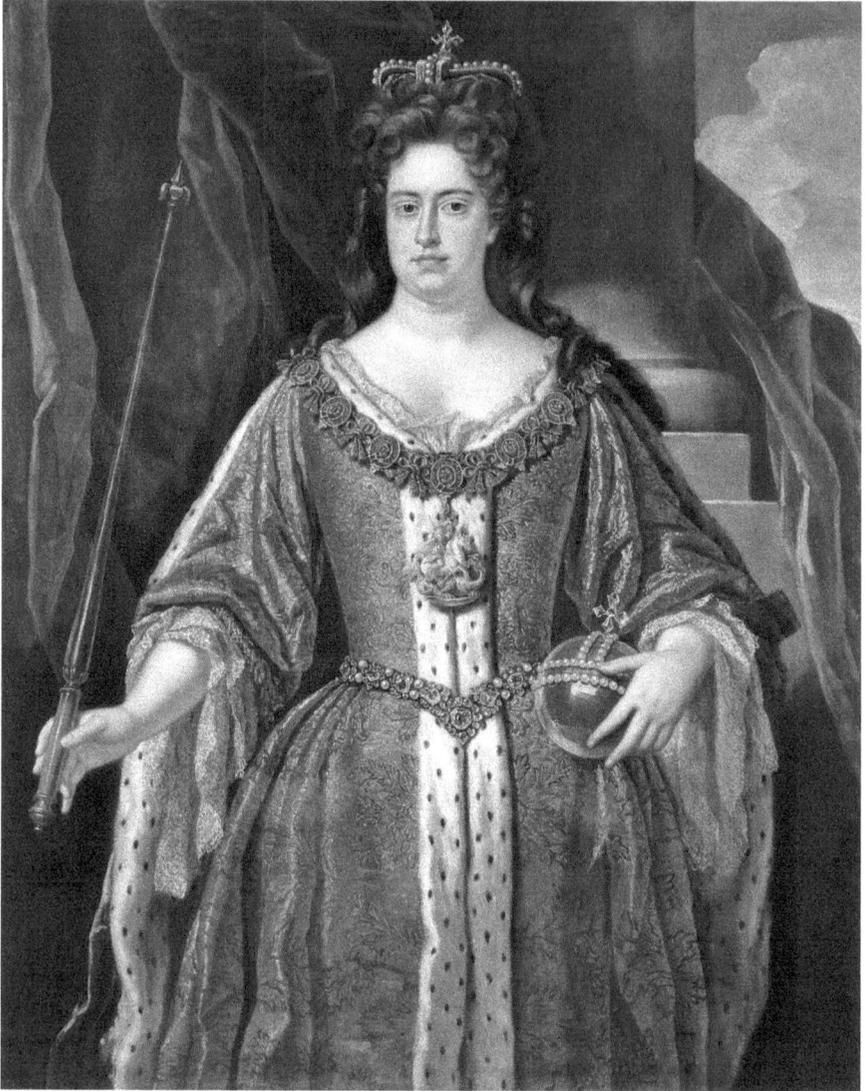

Queen Anne.

With the childless William and Mary and the death of Anne's last surviving child in 1700, Parliament scrambled to pass the 1701 Act of Settlement, which ensured a future Protestant monarchy by naming distant cousin Queen Sophia of Hanover (present-day Germany) as heir to the throne of England. Queen Anne's reign was punctuated by the 1707 Act of Union, which unified the thrones of England and Scotland, creating the Kingdom of Great Britain. When Queen

Anne died in 1714, Queen Sophia's eldest son, George, was of age and became King George I of Great Britain. He was not even able to speak English when he ascended to the throne, but his Protestant faith appeased his government backers. However, in Scotland and the north of England, there was strong sentiment that the deposed James II's Catholic son, James Francis Edward Stuart, should rightfully be King James III of Great Britain (his detractors referred to James as "the Pretender").

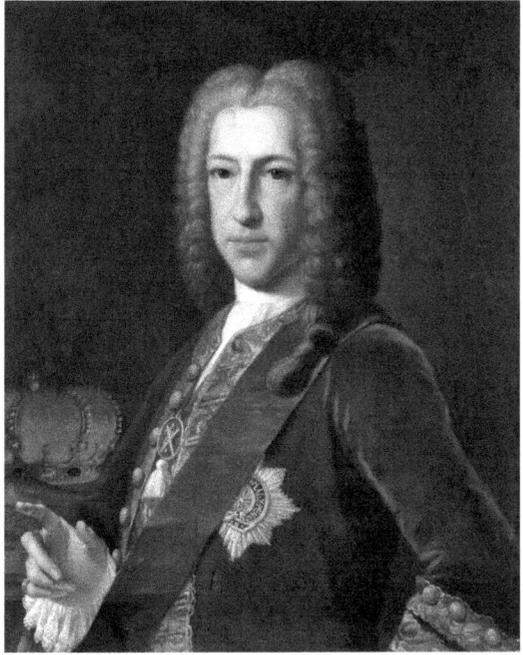

James Francis Edward Stuart, "the Pretender."

Those who supported James's claim to the throne came to be known as Jacobites. The pirates operating out of Nassau were overwhelmingly sympathetic to the Jacobite cause. News of a Jacobite armada of pirate ships invading Great Britain swept the Caribbean and America. There had been attempted Jacobite land invasions, like the unsuccessful 1715 uprising, which started in Scotland, so a Jacobite pirate assault, though unlikely, was not something that authorities in London dismissed lightly. The tenacious Jacobites staged fruitless uprisings and demonstrations for thirty more years, but no invading pirate fleet ever appeared off England's coast. Direct descendants of George I and the Hanoverian lineage still wear the crown today.

CHAPTER 2
A City on the Brink

Piracy has enjoyed a long and rich history along the South Carolina coast. More than a century before the founding of Charleston, Charles IX of France issued a charter to start a Huguenot colony in the New World. In 1562, two ships under the command of Jean Ribault dropped anchor to the south of Charleston, near Port Royal. A fort was constructed and named Fort Charles in honor of the king. Ribault returned to France, leaving behind a garrison of twenty-six men. In less than two years, the garrison had become so impoverished that some of the settlers built a small ship and tried to sail back to France. Out of provisions and with their already leaking boat further damaged by storms, the desperate crew turned to cannibalism for survival. Lots were cast, and one unfortunate member of the crew was sacrificed to feed the others. After weeks adrift at sea, the survivors were rescued by a passing English ship and returned to France.

When news reached the French king of the conditions at Fort Charles, René Goulaine de Laudonnière was sent with three ships to relieve the broken colony. Finding the conditions in the New World inhospitable, many of Laudonnière's crew mutinied upon their arrival and sailed away with one of the relief ships to pursue lives of piracy. Sailing south into the Caribbean, they found immediate success preying on Spanish merchantmen. They soon became so emboldened that they attacked the settlement in Jamaica, taking the governor hostage. However, the Spanish eventually mounted an expedition against the pirates and drove them back to the French colony, which had since moved south to Florida and been named Fort Caroline.

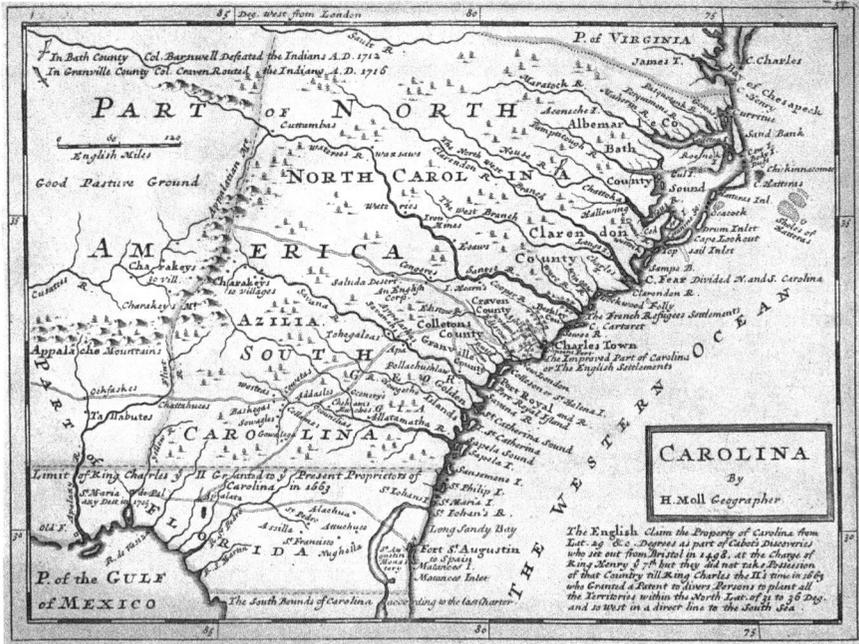

An early eighteenth-century map of the Carolinas. Note the absence of Georgia, which was not founded until 1733. The threatening Spanish St. Augustine can be seen marked on the map.

Laudonnière had them arrested and hanged as an "example to posterity." Shortly afterward, the colony at Fort Caroline was massacred by a force sent from the Spanish walled city at St. Augustine, and France abandoned its attempt to settle on America's eastern coast.

In 1663, King Charles II gave eight Lord Proprietors the land called Carolina. King Charles II's father, the former King Charles I, had been beheaded in 1649 at the culmination of the English Civil War. A more than decade-long period followed without a monarch on England's throne. With Charles II's restoration to the throne in 1661, favors were granted to those who had remained loyal to the royal family. Among these favors was the Carolina land grant to these eight Lord Proprietors. Unlike royal colonies, such as Virginia, the proprietary colony of Carolina resembled more of a real estate investment than an imperial foundation in the New World. None of the Lord Proprietors would ever visit, much less live in, their province of Carolina.

When Charleston was founded in 1670, it did not take long for the settlers to realize the difficulties of life under the rule of a proprietary

government. Anthony Ashley Cooper, one of the eight Lord Proprietors, referred to Carolina as his "darling," but for those carving out a trading hub on the peninsula between the Ashley and Cooper Rivers, it was clear that little support could be expected from their wealthy patrons back in England. With the nearby Spanish-held Florida, the earliest settlers of Charleston began building defenses, and by the early eighteenth century, Charleston was comprised of a walled fortress approximately one mile wide by a half mile deep. The walls ran roughly north to south from present-day Cumberland Street to Water Street and east to west from East Bay Street to Meeting Street. The popular Market Street of today was a creek that provided a natural moat for the northern wall. Water Street, until the early nineteenth century, was the location of Vanderhorst Creek, which snaked under palisades into the interior of the city. Six diamond-shaped bastions dotted the works with smaller, triangle-shaped redoubts positioned between them. At the foot of Broad Street, facing the Cooper River and the expanse of the harbor, was the Half Moon Battery, which contained the Court of Guard building and served as the city's military center. To the southeast stood Granville Bastion, armed with cannons of various calibers, from which defenders could command the harbor. However, what the citizenry of Charleston wanted and continually requested from the Lord Proprietors was a naval warship to protect them from an attack by sea. But like absent,

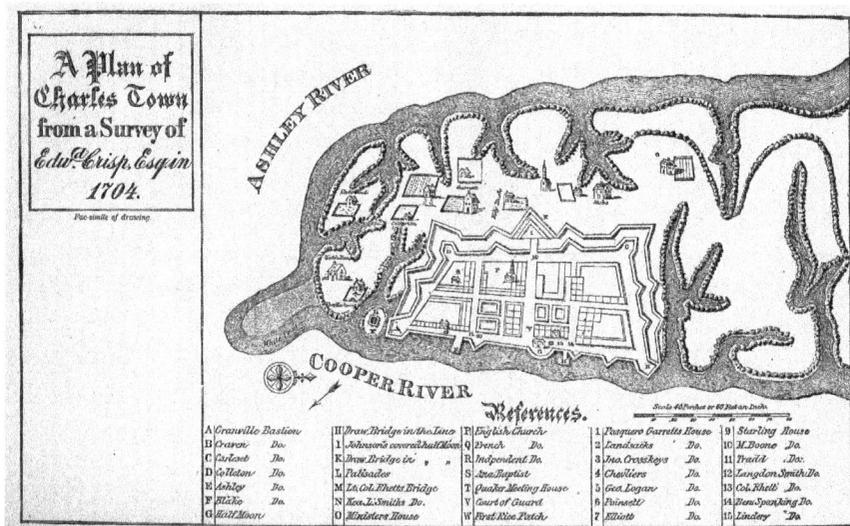

Edward Crisp's 1704 map of the walled city of Charleston.

miserly landlords, the Lord Proprietors were never anxious to spend money on their investment, and the request was never granted.

Twenty-one different governors were sent by the Lord Proprietors from 1670 to 1719 to manage the increasingly defiant and unruly people, but most were found ineffective or even corrupt and recalled back to England. In 1686, a Spanish force sent from St. Augustine landed south of Charleston near the Edisto River and started a campaign of destroying plantations and killing settlers. An angry, vengeful force of Charleston citizens assembled to launch a counterattack on St. Augustine, but the recently arrived Governor Colleton ordered the expedition abandoned—threatening to hang those who resisted his authority. The Charlestonians considered Colleton's actions to be a stain on their honor, and their respect for the Lord Proprietors and appointed governors further diminished.

The proprietary governors were finding their station and their relations with the province's citizens difficult as well. Thomas Smith, who became governor in 1693, resigned his post in less than a year, writing, "It was impossible to settle the country unless a Proprietor himself was sent over with full power to heal their grievances." The Carolina Assembly wrote directly to the king petitioning for royal intervention, but it was decided that the government could do nothing unless the Proprietors ceded the colony to the Crown. The Lord Proprietors seemed to recognize the futility of the situation. Lord Carteret wrote to the Trade Commission, "We, the Proprietors of Carolina, having met on this melancholy occasion, to our grief find that we are utterly unable of ourselves to afford our colony suitable assistance in this conjuncture, and unless his Majesty will graciously please to interpose, we can foresee nothing but the utter destruction of his Majesty's faithful subjects in those parts." Unfortunately for those "faithful subjects," it would take until 1719 before South Carolina would shed its Lord Proprietors and become a royal government.

In August 1706, the people of Charleston's greatest fears were realized when a combined French and Spanish fleet of six vessels, led by the frigate *Soleil*, appeared in the harbor. A defensive fleet—including the vessels *Crown Galley*, *Mermaid*, *Richard*, *William*, *Flying Horse* and *Seaflower*—with a total of more than thirty guns and three hundred men, was quickly assembled. The sight of such a powerful force was enough to convince the enemy fleet to retreat, but the "invasion" proved Charleston's vulnerability to assault by sea. Starting in 1715, the colony was further weakened by a series of battles and massacres at the hands of various surrounding Native American tribes that collectively came to be known as the Yemassee War.

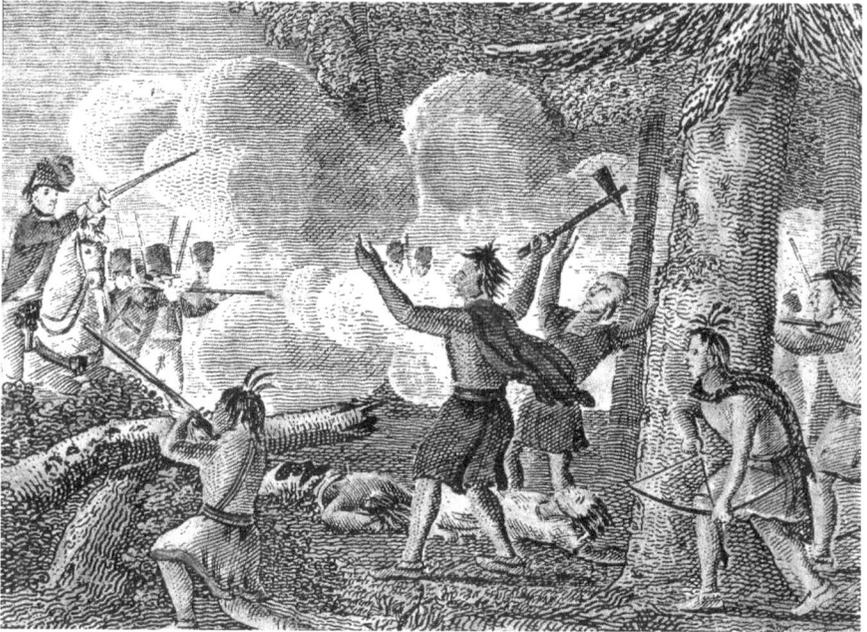

An engraving from John Barber's *Elements of History* (1814) depicting an engagement between Carolina militia and Native Americans during the Yemassee War. *Image courtesy of the Powder Magazine Museum.*

Farmers and settlers from the surrounding countryside poured into the walled city as they fled from the hostile tribes. An outbreak of yellow fever struck overpopulated Charleston, and food ran short as unattended farms failed to produce crops.

From its earliest days, the troubled and weakly governed Charleston became a haunt for pirates. As early as 1684, complaints of pirates operating out of Charleston were reaching the ears of the government in London. In that same year, Sir Thomas Lynch, governor of Jamaica, filed an official complaint with the lords of the Committee for Trade and Plantations in which he described "the great damage that does arise in his majesty's service by harboring and encouraging pirates in Carolina."

The irony and insult of a complaint of piracy coming from Jamaica was not lost on the citizens of Charleston. Jamaica had previously been the epicenter of piracy. King Charles II had even named Henry Morgan, arguably history's most prolific pirate, as the lieutenant governor of Jamaica in 1675. Governor Lynch had been sent in 1681 to break up the piratical hold in Jamaica and enforce the Jamaica Laws, which directly

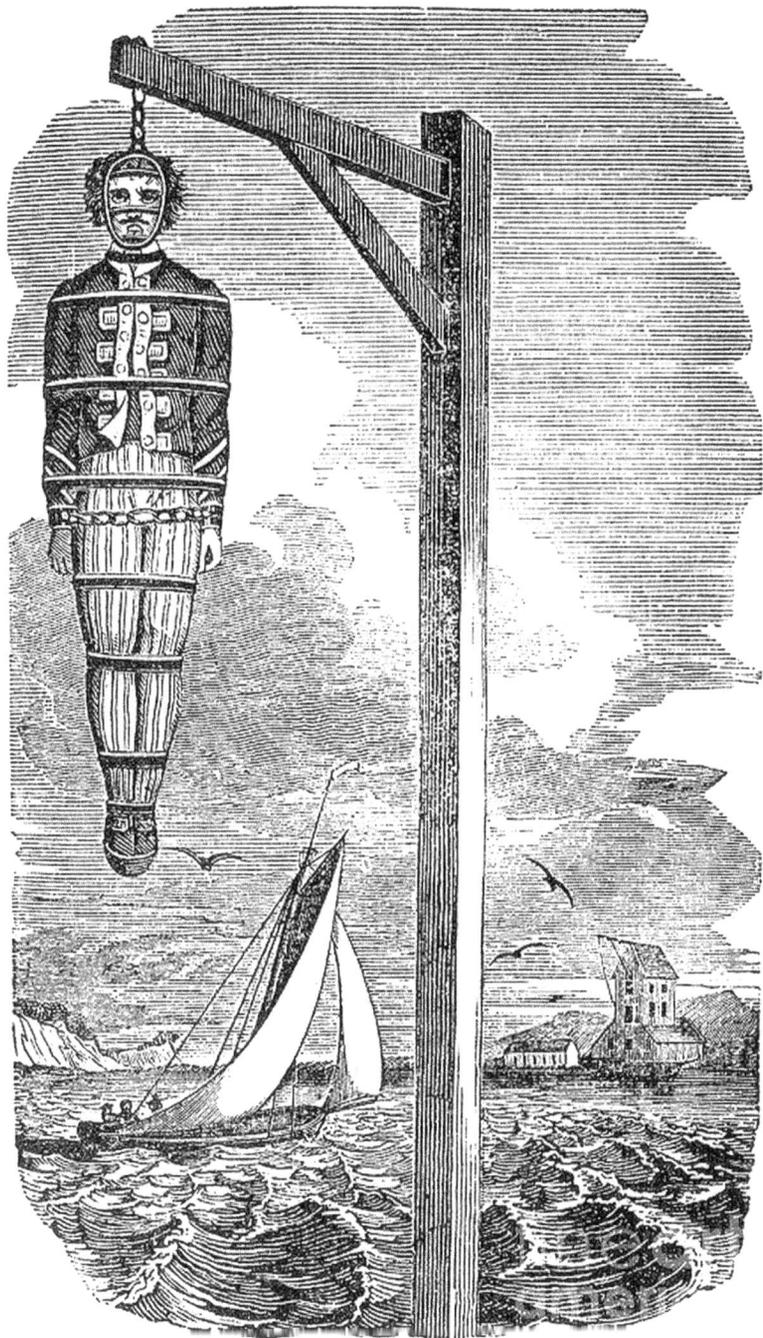

A pirate hung in gibbets as a warning to others of the penalty for piracy.

addressed the suppression of piracy. The enactment of the Jamaica Laws and a devastating earthquake that destroyed the pirate stronghold of Port Royal on June 7, 1692, brought an end to Jamaica's long history as the Caribbean's pirate haven.

When the complaint from Governor Lynch reached the Lord Proprietors, the naïve Lord Craven responded that he knew of only one pirate who had come to Carolina, and he had been captured, convicted and hanged in chains at the entrance of the harbor, "and there hang to this day for an example to others." Regardless, the king sent orders that the Jamaica Laws be enacted as a statute in the Carolina province. The Carolina Assembly complied and, in February 1687, further honored its commitment to fighting piracy by passing the act "for the suppressing and punishing privateers and pirates," which addressed the conviction and punishment of those who conspired with and profited from pirates. However, these statutes did little to quell the cooperation and encouragement of piracy in Charleston—even within its own government.

In 1684, it was recommended by the Lord Proprietors that "as the governor will not in all probability always reside in Charles Town, which is so near the sea as to be in danger from a sudden invasion of pirates, the governor should commissionate [sic] a particular governor for Charles Town who may act in his absence." In April of the same year, Governor Richard Kyle chose Robert Quarry, secretary of the province, for this position. Although Quarry had a good reputation and had served previously in several offices of the government of the colony, he was dismissed from his post within two months for "flagrant encouragement of pirates." When Governor Colleton took his post in 1686, one of the first acts of his administration was the dismissal of John Boon from the provincial council "for holding correspondence with pirates." In 1710, Peter Painter was nominated for the coveted position of public powder receiver, but he was rejected by the assembly, which reported, "Mr. Painter having committed piracy, and not having his Majesties pardon for the same, it is resolved he is not fit for that trust."

Law officials and courts were either impotent or unwilling to prosecute the pirates who had overrun the city. Bribery ran rampant through the judicial system, causing the assembly to pass an act "to provide for indifferent jurymen in all causes civil and criminal," which was refused by the Lord Proprietors on the grounds that it was "very unreasonable, and many ways dangerous and tending to the lending [leaving] the most enormous crimes unpunished, especially piracy." A group of pirates who arrived in Charleston after their ship wrecked off the coast boasted openly of their indiscretions in the Red

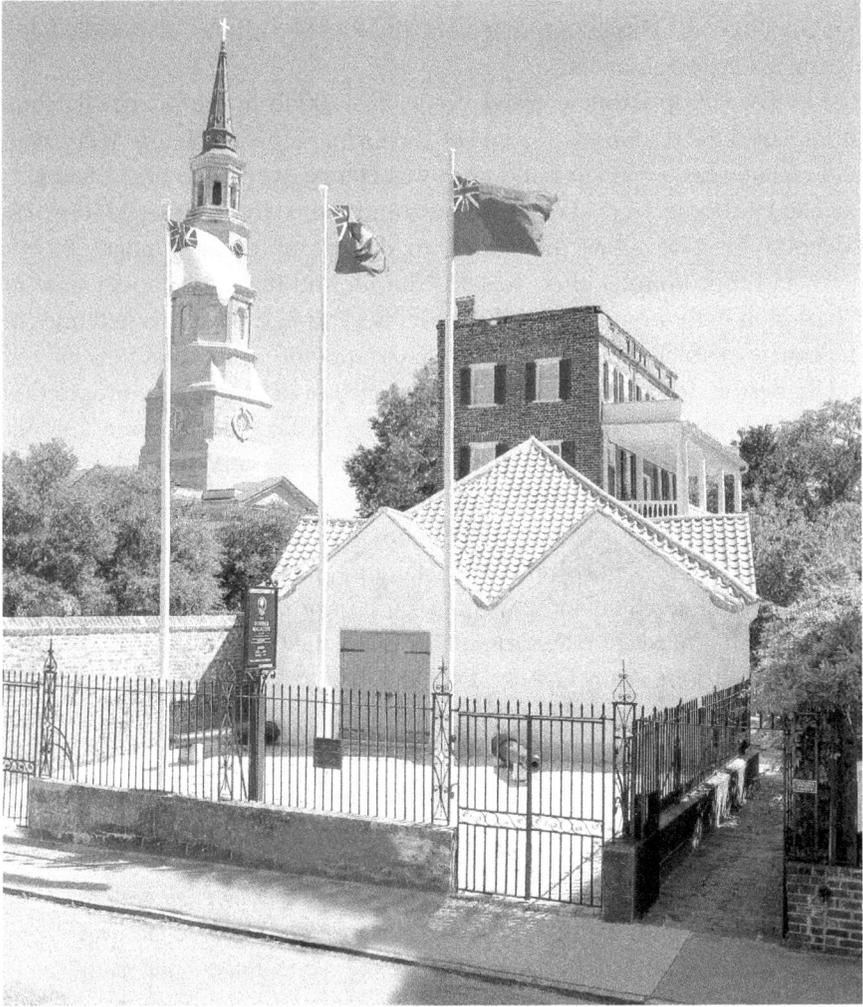

The Powder Magazine, which was built in 1713 as a safe storage facility for gunpowder, is South Carolina's oldest public building. Today, it serves as a colonial military museum. Visit the Powder Magazine at PowderMag.org. *Image courtesy of the Powder Magazine Museum.*

Sea, including plundering vessels of the grand mogul. The pirates were never brought to justice, and Edward Randolph, surveyor general of customs, wrote back to England that the pirates "were entertained, and had liberty to stay or goe to any other place." Their presence, however, did prompt the Lord Proprietors to change a law that determined the requirements for a man to be able to vote for representatives. The law had previously required a man to possess only £10 or property worth the same amount in order to be

qualified to vote. This meant that all of the Red Sea pirates, rich with stolen treasure, were legal voters.

The Lord Proprietors received a letter in 1700 from the Board of Trade that relayed the testimony of some of the former crew of Henry Avery, who had recently been tried in London. It was Henry Avery who had sailed into Nassau Harbor in 1696 aboard the *Fancy* and bribed the disgraced Governor Nicholas Trott to allow the pirates to dispose of their plunder. Avery's crew had split up after their visit to Nassau, and many had spent time in Charleston before returning to England. Several had been arrested and, in the course of their trial, described the infestation of pirates that now existed in Charleston. It was this testimony and other stories of pirate improprieties, both real and unfounded, that pushed King William III to issue an "Act of Grace" in 1701. Believing that most pirates were anxious to leave their lives of crime behind, this act essentially offered pardon to pirates for illegal deeds committed prior to a specified date. A pirate was simply required to turn himself in to a government official and swear an oath of allegiance. It is impossible to calculate how many pirates took advantage of the king's offer and even harder to determine how many men returned to piracy after receiving pardon. King George I would issue a similar proclamation in September 1717 that read:

> BY THE KING, A PROCLAMATION, FOR SUPPRESSING PYRATES
> *Whereas we have received Information, that several Persons, Subjects of Great Britain, have since the 24th day of June, in the Year of our Lord 1715, committed divers Pyracies and Robberies upon the High-Seas, in the West Indies, or adjoining to our Plantations, which hath and may Occasion great Damage to the Merchants of Great Britain, and others trading into those Parts; and tho' we have appointed such a Force as we judge sufficient for suppressing the said Pyrates, yet the more effectually to put an End to the same, we have thought fit, by and with the Advice of our Privy Council, to Issue this our Royal Proclamation; and we do hereby promise, and declare, that in Case any of the said Pyrates, shall on or before the 5th of September, in the Year of our Lord 1718, surrender him or themselves, to one of our Principal Secretaries of State in Great Britain or Ireland, or to any Governor or Deputy Governor or any of our Plantations beyond the Seas; every such Pyrate and Pyrates so surrendering him, or themselves, as aforesaid, shall have our gracious Pardon, of and for such, his or their Pyracy, or Pyracies, by him or them committed before the fifth of January next ensuing. And we do hereby strictly charge and command all*

our Admirals, Captains, and other Officers at Sea, and all our Governors and Commanders of any Fort, Castles, or other Places in our Plantations, and all other our Officers Civil and Military, to seize and take such of the Pyrates, who shall refuse or neglect to surrender themselves accordingly. And we do hereby further declare, that in Case any Person or Persons, on, or after, the 6ᵗʰ Day of September 1718, shall discover or seize or cause or procure to be discovered or seized, any one or more of the said Pyrates, so refusing or neglecting to surrender themselves as aforesaid, so as they may be brought to Justice, and convicted of the said Offence, such Person or Persons, so making such Discovery or Seizure, or causing or procuring such Discovery or Seizure to be made, shall have and receive as a Reward for the same, viz. for every Commander of any private Ship or Vessel, the Sum of 100 pounds sterling for every Lieutenant, Master, Boatswain, Carpenter, & Gunner, the Sum of 40 pounds sterling for every inferior Officer, the Sum of 30 pounds sterling for every private Man, the Sum of 20 pounds sterling. And if any Person or Persons, belonging to and being Part of the Crew of any such Pyrate Ship or Vessel shall on or after the said sixth Day of September, 1718, seize and deliver, or cause to be seized or delivered, any Commander or Commanders, of such Pyrate Ship or Vessel, so as that he or they be brought to Justice, and convicted of the said Offence, such Person or Persons, as a Reward for the same, shall receive for every such Commander, the Sum of 200 pounds sterling which said Sums, the Lord Treasurer, or the Commissioners of our Treasury for the Time being, are hereby required, and desired to pay accordingly.

Given at our Court, at Hampton-Court, the fifth Day of September 1717, in the fourth Year of Our Reign.

George R.
God save the KING.

Among those in Charleston who applied for King William's 1701 pardon were several pirates who had sailed with the infamous Captain William Kidd. Kidd had settled in New York City and become an esteemed citizen after having grown wealthy from service on a privateer vessel that had fought against the French in the Caribbean in 1689. Kidd increased his fortunes in May 1691 when he married Sarah Bradley Cox Oort, one of the wealthiest widows in New York. The former privateer was active in local politics and had even helped finance the construction of the Trinity Church in Manhattan, but Kidd was restless and anxious to leave behind his sedentary life among New York's social elite and return to a life of adventure on the high seas. In

1695, Richard Coote, First Earl of Bellomont and governor of New York, Massachusetts Bay and New Hampshire, commissioned the "trusty and well beloved Captain Kidd" to hunt for pirates and enemy French vessels on the newly built privateer *Adventure Galley*. Kidd's letter of marque was signed by the highest authority: King William.

Spirits were high when the *Adventure Galley* sailed out of New York Harbor in early 1696, but the expedition met almost immediately with misfortune. Few prizes were taken, and crew morale sank. Dissent and threats of mutiny spread throughout Kidd's crew. During a dispute with the crew over Kidd's refusal to attack a Dutch merchantman, Kidd struck a crew member, William Moore, with a bucket. Moore's skull was fractured, and he died the next day. Aimlessly sailing through the Indian Ocean and desperate to capture a prize to ease tensions with the crew, Kidd made the questionable decision to seize the treasure-laden *Quedah Merchant*. The *Quedah Merchant*'s captain was English but was carrying papers from the French East India Company. Kidd considered his actions legal because of the prize's French papers, but to the *Quedah Merchant*'s captain and many others, Kidd had committed an act of outright piracy.

News of the *Quedah Merchant*'s capture by Kidd quickly reached Bellomont, who had since moved to Boston. Anxious to clear his own name and disassociate himself with a pirate, Bellomont lured Kidd to bring the *Adventure Galley* into Boston, where he was promptly arrested. For over a year, Kidd languished in solitary confinement and was driven to near insanity until he was finally sent to London to stand trial. By the time of his trial in 1701, Kidd's only real defense—the *Quedah Merchant*'s French papers—had conveniently been lost. Those who six years earlier had financially backed the *Adventure Galley*'s privateer expedition abandoned Kidd and testified against him. Kidd was found guilty of piracy and of the murder of William Moore. Sentenced to death, the dejected Kidd told the judge, "My Lord, it is a very hard sentence. For my part, I am the innocentest person of them all, only I have been sworn against by perjured persons."

Kidd was hanged at Execution Dock at Wapping in London in May 1701. According to a letter written by William Penn in February 28, 1701, several of Kidd's former crew, led by a man named Rayner, had settled as planters in the Carolina province. Perhaps it was the news of their former captain's fate in London that drew the pirates to Charleston to surrender themselves shortly after the arrival of the king's "Act of Grace."

By the end of Queen Anne's War in 1713, the tolerant and even welcoming spirit that pirates had enjoyed in Charleston was wearing thin. A new group

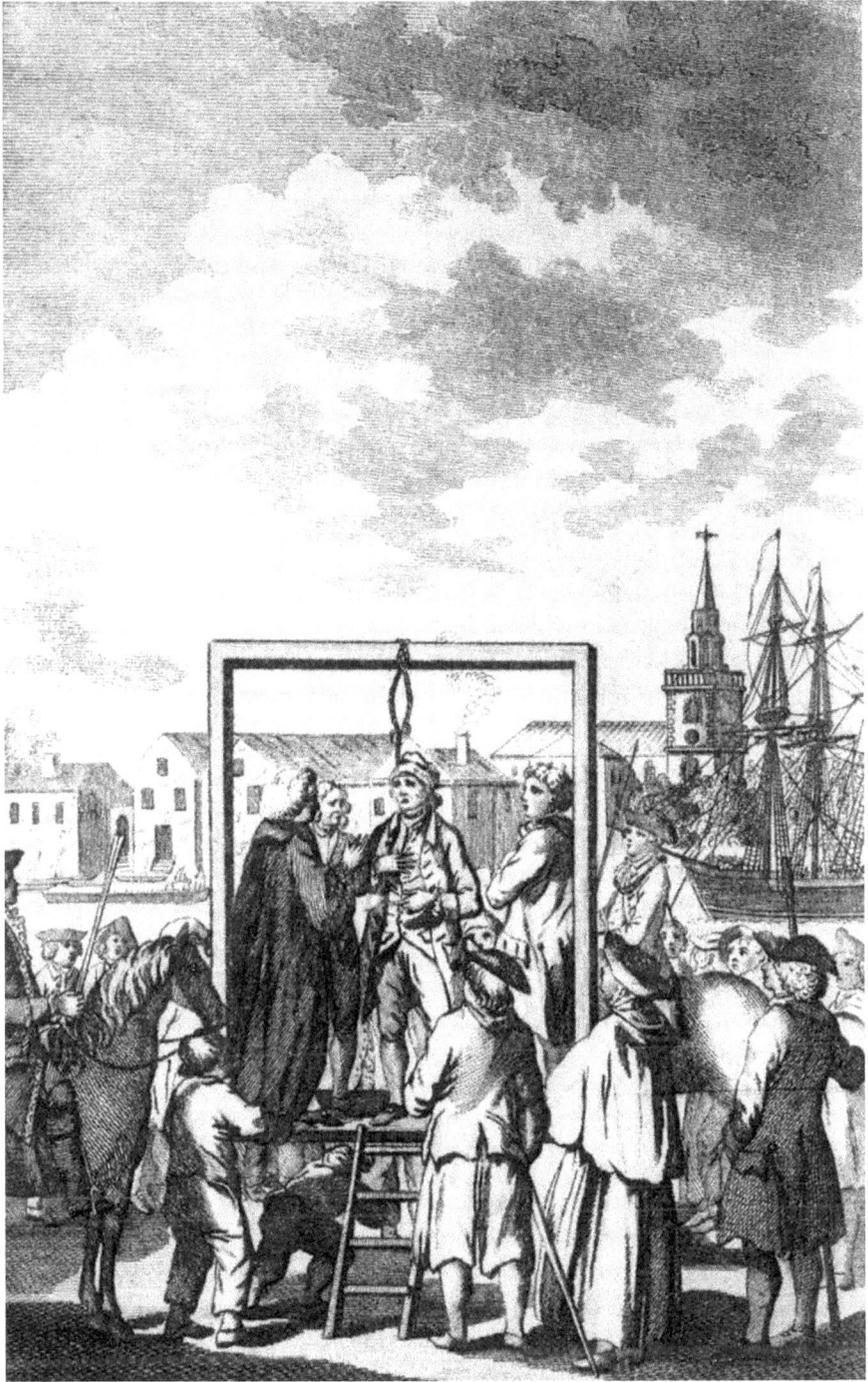

The scene of a pirate hanging at Execution Dock at Wapping on the Thames River, London.

of immigrants were growing in number and influence. Thriving in the Carolina province, and unlike many of those who had come before them to settle the Lowcountry, this newly arrived contingent of French Huguenots did not condone the pirates' flagrant offenses. In 1685, King Louis XIV of France declared Protestantism illegal and revoked the Edict of Nantes, which had offered the Huguenots protection from persecution for nearly a century. Huge numbers of Huguenots fled France, and many settled in and around Charleston. By the start of the early eighteenth century, French could be heard spoken on the streets of Charleston nearly as often as English. A hardworking and pious people, the Huguenots did not look kindly upon the pirates and their wicked lifestyles.

A shift in the economy was also signaling the end to Charleston's hospitality to pirates. The colony had found success with timber, indigo and silk, but it would be rice that would transform the struggling province of Carolina. The low, swampy lands around Charleston were perfect for the production of rice, and as the demand for rice on Europe's dinner tables increased, so did the wealth of the colony. An affluent class of plantation owners emerged. Merchant vessels loaded with rice were departing from Charleston and then returning with their holds full of Europe's finest clothes, furniture and other household goods for Carolina's burgeoning social elite. The Lowcountry land barons were losing a fortune to the pirates operating in the waters around Charleston, and pressure was mounting on the government to intervene. Even vessels on the rivers around Charleston delivering goods to and from the plantations and the city were not immune to attack. By 1720, the problem of these river pirates had become such an issue that instructions were sent from England for a special flag to be flown by all private vessels of "good standing" operating in the waterways around Charleston. The instructions to Francis Nicholson, captain general and commander in chief of the province, read:

> *Whereas great inconveniences do happen by merchant ships and other vessels in the plantations wearing the colours worn by His Majesty's ships of war under pretense of commissions granted to them by the governors of the said plantations, and that by trading under these colours not only amongst His Majesty's subjects, but also those of other princes and states, and committing divers irregularities, they do very much dishonour His Majesty's service. For prevention whereof you are obliged the commanders of all ships to which you shall grant commissions to wear no other jack than according to the sample here described, that is to say, such as worn by His*

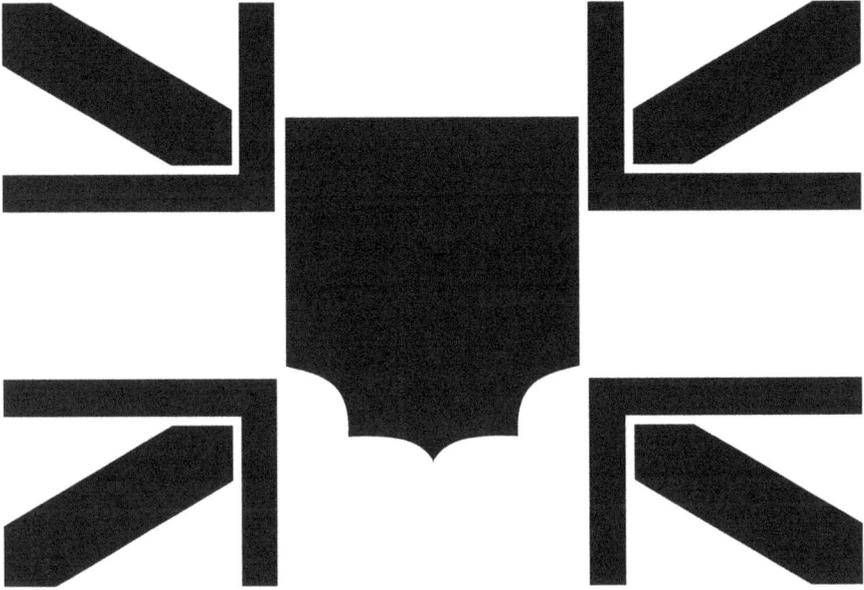

An artist's rendering of the flag required by authorities to be flown by vessels of "good standing" in the waterways around Charleston to differentiate merchant vessels from pirates. *Picture by Paula M. Sokoloski at SignDesign, Mount Pleasant, South Carolina.*

Majesty's ships of war, with the distinction of a white escutcheon in the middle thereof and that the mark of distinction may extend itself to one-half of the depth of the jack and one-third of the fly thereof.

In 1716, the court system in Charleston was revamped to offer more authoritative power to try and convict pirates. Previously, questions of jurisdiction had caused the release of many pirates, and many more had to be sent to England to face trial. In 1716, the Lord Proprietors, perhaps overstepping the boundary of their powers, appointed Nicholas Trott as vice-admiralty judge in Charleston. The commission of a vice-admiralty court was normally only at the discretion of the king and Parliament, but with the growing lawlessness of the colony, the Proprietors' appointment does not seem to have been second-guessed. With a strong vice-admiralty court in place in Charleston, the Lord Proprietors hoped to offer a degree of protection from pirates to their growing financial investment.

Nicholas Trott was born in London into a less-than-influential family of drapers and tradespeople. However, his family had fostered some powerful business and marital connections. The precocious Nicholas studied law at

the Inner Temple and, upon his graduation, was named secretary to the attorney general of Bermuda. Conniving, bullying and almost fanatical in his religious beliefs, Trott was appointed chief justice of South Carolina in 1703, where he presided over civil and criminal matters. Fluent in several languages, Trott spent his spare time laboriously translating and explicating the original Hebrew Bible into English. Among his more famous trials in his capacity as chief justice were the proceedings against a Charleston woman who stood convicted of witchcraft. When the woman's defense counsel dismissed the existence of witches, the evangelical Trott countered:

> We live in an Age of Atheism and Infidelity, and some persons that are no great friends to religion, have made it their Business to decry all stories of apparitions and of witches...yet that there are such creatures as witches I make no doubt: neither do I think they can be denied without denying the truth of the Holy Scriptures or most grossly perverting them. Now that the Holy Scriptures do affirm that there are witches is evident from so many places that might be produced out of them that time will not permit me to cite them to you.

In a later trial, Trott sentence a woman to be burned alive for the murder of her husband, citing the offense as petty treason, for which Trott's interpretation of the common law did allow for burning. However, there is no record that the woman was ever burned.

In 1713, Trott would garner the mistrust and hatred of many of his peers in Charleston. Trott applied for and received paid leave from the Lord Proprietors, upon which he returned to England. He used his time in London to fully ingratiate himself with the Proprietors, subsequently obtaining unprecedented authority to take back to Charleston. The Proprietors issued orders that Trott was to be named a member of the governor's council, and without his presence there could be no quorum called. Trott was to be consulted for every proposed measure in the province, and he had the power of veto over the council. His new powers outweighed those of even the current governor, Charles Craven. The governor declared, "A power in one man, not heard of before!" The assembly called it "an exorbitant power unheard of in any British dominions, for aught we know in the whole world!" When charges were leveled against him by the assembly for corruption in his role as chief justice, including "that he had been guilty of many partial judgments; that he had contriv'd many ways to multiply and increase his Fees contrary to Acts of the Assembly, and the great grievance of

the subjects, and that among other he contriv'd a Fee for continuing Causes from one Court (or Term) unto another, and then he put off the Hearing for several Years together," Trott refused to recognize the authority of the assembly and proclaimed that he answered only to the Lord Proprietors. In February 1716, the Proprietors yielded to the protests of the assembly and revoked some of Trott's powers, including his right to veto council decisions. However, in his role as vice-admiralty judge, Trott would flourish.

Known for his lengthy citing of both civil and biblical laws in his sentencing, Trott would be a scourge to the pirates in his capacity as vice-admiralty judge. His condemnation arose not only from his piety and high station but also from a desire to regain family honor. It was his uncle, and namesake, Governor Nicholas Trott of the Bahamas, who had brought shame to the

Nicholas Trott.

Trott name by harboring Henry Avery and his pirates in Nassau in 1696. Historians have confused vice-admiralty judge Nicholas Trott with his uncle for more than three hundred years.

In November 1716, Trott presided over his first pirate trial as vice-admiralty judge. Nine men were indicted for the August 2 seizure of the vessel *Providence*. The *Providence* was owned by two Charleston merchants, William Gibson and Andrew Allen. All nine men were found not guilty for lack of evidence. In June 1717, the vice-admiralty court convened again to hear three indictments against Stephen James De Losey, Francis Demont, Francis Rusoe and Emanuel Ernandos. The indictments included charges that the four men captured the *Turtle Dove* and the *Penelope* near Jamaica, the sloop *Virgin Queen* off the east coast of Cuba and the *Tanner* near Crooked Island in the Bahamas. The indictment for the seizure of the *Turtle Dove* stated that the three men had "imprisoned him (the Captain) and his crew on the vessel in bodily fear of their life." All four men pleaded not guilty to all three indictments, and a jury was drawn on June 24. The court adjourned on July 3, with the jury finding De Losey, Rusoe and Ernandos guilty. The court transcript records Trott's announcement of the verdict and sentencing:

> *The prisoners, Stephen James De Losey, Francis Rusoe and Emanuel Ernandos, who stood convicted of piracy, as appears by the above records being brought to the bar and being severally asked what they could say why judgment of death should not pay against them and they having nothing to allege in arrest of judgment, the judge of the vice admiralty, as president of this court of admiralty sessions, gave sentence that the said Stephen James De Losey and Francis Rusoe and Emanuel Ernandos should go to the place from whence they came and there be severally hanged by the neck till they are several dead.*

The hanging of the three men was not only a clear statement that pirates were no longer welcome or tolerated in Charleston but also that the courts now had the authority and conviction to pass the ultimate judgment and sentence. The timing was ideal, as alarming rumors of pirate activities in Nassau were reaching Charleston. In 1717, George Logan, speaker of the assembly, wrote in the same letter that requested the retaining of the warship *Shoreham* in Charleston Harbor:

> *May it please your Honors: As this House has received information that the Governor of St. Augustine having advice and intelligence sent*

from the Governor of Havana, to be upon his guard, by reason of the design the Pirates at the Bahama Islands (and who are numerous) have to attack them; and as we cannot suppose, that any such persons have a regard to, or make any difference or distinction, between the people of any nation whatsoever.

The year 1718 would find Charleston's citizens, government, courts and even the city's honor at center stage of the Golden Age of Piracy.

CHAPTER 3

A Gentleman Pirate

On September 22, 1717, a brigantine slowly crept across Charleston Harbor toward the walled city. Although a vessel of its size could carry hundreds of square feet of sail, it was limping toward Rhett's Wharf under a single frayed foresail. When the struggling ship was safely tied alongside the dock, two emaciated men staggered down the gangway and presented themselves as Captain Palmer and Captain Porter. Both requested an audience with Governor Robert Johnson.

Governor Robert Johnson, whose office stood on Bay Street, had filled his post as governor only a few months earlier. His father, Nathaniel Johnson, had served as governor from 1702 to 1709. Nathaniel Johnson had initially been denied the Lord Proprietors' request to be made governor because of his public Jacobite sentiments. King William III had removed him as governor of the Leeward Islands because of these political leanings, but Queen Anne was able to excuse his perceived flaws and accept the Lord Proprietors' nomination. Nathaniel Robert's tenure as governor was marked by progress and merit. He had guided the province through the Franco-Spanish invasion, strengthened the city's defenses and secured the passage of the 1706 Church Act, which ended religious sectarian strife in the colony. The Lord Proprietors hoped that Governor Robert Johnson bore the same strong leadership skills as his father.

The Lord Proprietors' commission to Robert Johnson granted the new governor a salary of £400 sterling per year. Among his instructions from the Lord Proprietors was to collect the increasing amount of past-due rent from

citizens, which had become a great frustration to the Proprietors. Further, Johnson was to enforce what came to be called the "Bank Act," which aimed to reduce paper credit that was being rampantly circulated among the poor, struggling population. The Proprietors' sense of frustration toward the province's citizens was not mutually exclusive. The movement for the end of proprietary government was gaining momentum, and as Robert Johnson was preparing to sail for Charleston, King George received a letter from agents of the assembly in Charleston titled "The Humble Address of the Representatives and Inhabitants of South Carolina." The letter read:

> *In our last humble address to your Majesty we took the liberty to inform your Majesty of the deplorable circumstances we then labored under, without any probability of seeing an end to our calamities. Our troubles instead of coming to a period, daily increase upon us, and we now see ourselves reduced by these, our misfortunes to such a dismal extremity, that nothing but your Majesty's most Royal and gracious protection (under God) can preserve us from ruin. Our Indians continue committing so many hostilities and infesting our settlements and plantations to such a degree, that not only those estates which were deserted at the breaking out of the war, cannot be resettled, but others are daily likewise thrown up to the mercy of the enemy to the impoverishment of several numerous families.*
>
> *We further take the liberty to inform your Majesty that notwithstanding all these miseries, the Lord Proprietors of the Province instead of using any endeavours for our relief and assistance, are pleased to term all our endeavours to procure your Majesty's Royal protection the business of a faction and party. We most humbly assure your majesty that it is so far from anything of that nature, that all the inhabitants of this Province in general are not only convinced that no human power but that of your Majesty can protect them, but earnestly and fervently desire that this once flourishing Province may be added to those under your happy protection.*

Burdened by a colony on the brink of revolution or ruin, Governor Robert Johnson could not have imagined that the remarkable story that Captain Palmer and Captain Porter were about to report would be the preface of a cancer that would come to dominate his administration.

The two bedraggled captains were ushered into the governor's office, where they reported an act of piracy just off the coast of Charleston. Considering the long history of pirate activity around Charleston, the report initially did not seem out of the ordinary. However, the disheveled captains

explained that the attack had occurred more than a month earlier and had been at the hands of a most unlikely pirate.

Nearly six weeks prior, Captain Thomas Porter had been sailing south from Boston in the brigantine that was now tied up at Rhett's Wharf. Porter's vessel rode high in the water with its holds empty, waiting to be filled with Carolina rice. Just off Sullivan's Island, a sloop approached from the west with a black flag snapping at the mast top and ten cannons hauled through her portholes. The pirate sloop *Revenge* had the advantage of the southwesterly wind. Porter had no room to maneuver and attempt escape. He gave the order to hove to and surrender. The pirates who boarded the brigantine were disappointed to find little of value, and they took Porter back to their ship to be interrogated by their captain.

In the great cabin of the *Revenge*, Porter was greeted by an overdressed, pudgy man who introduced himself as Captain Edwards. His cabin was lined with shelves stocked with hundreds of books. Captain Edwards seemed uncomfortable, and he nervously tugged at his powdered wig as he spoke with Porter. As Captain Edwards was questioning Porter about his ship's manifest and cargo, the call of "Sail to windward!" came from the deck. The pirates quickly secured Porter's crew and left a prize crew on the brigantine as the *Revenge* set off in pursuit of her new prize.

Captain Palmer, at the helm of the approaching Barbadian sloop, was as helpless against the *Revenge* as the now detained Captain Porter had been. Once the pirates climbed onboard Palmer's sloop, the disappointment of Porter's empty brigantine was quickly forgotten when the new prize's hatches were found to be filled with sugar, rum and slaves. While the pirates rummaged through the cargo, Captain Palmer was ushered to the *Revenge* to meet Captain Edwards. Another interview was held in the great cabin, but the questioning was abruptly cut short when Palmer informed Captain Edwards that his sloop hailed from Barbados. After a short meeting with his crew, Captain Edwards informed both Palmer and Porter that their ships would be sailing north in consort with the *Revenge* to the Cape Fear River to assist in careening the pirate ship's hull.

In warm tropical and semitropical waters, barnacle, worms and other aquatic parasites attach themselves to the hulls of wooden vessels and bore tiny holes. Without removing these parasites through a process called careening, there was not only a threat to the integrity of a wooden vessel's hull but also a reduction in vessel speed. A few days after leaving Charleston, the *Revenge* and her two prizes arrived at the Cape Fear River. The *Revenge* slipped into the river's shallows at high tide, exposing her hull as the tide fell.

Using the captured sloop and brigantine, the *Revenge* was hauled over first on her starboard side, exposing the hull on her port side. When the tide fell, the crew burned and scraped the barnacles off and repaired any damages. On the next tide, the *Revenge* was pulled over onto her port side and the cleaning completed on the rest of the hull.

With the *Revenge*'s careening completed, Porter and Palmer were recalled to Captain Edwards's cabin. Palmer was horrified to learn that that he, his crew and the cargo of slaves were to be transferred to Porter's brigantine and the Barbadian sloop to be set on fire. In an effort to slow news of the pirates' whereabouts from reaching authorities in Charleston, Captain Edwards ordered Porter's overcrowded ship to be relieved of most of her sails and rigging before being released. The voyage to Charleston should have taken less than a week, but with the missing canvas and struggling against a contrary current, it would take nearly four weeks before the brigantine and the near-starved crew reached Charleston on September 22. During their slow voyage south, Palmer and Porter, desperately short on provisions, were forced to put ashore and release all of the slaves "into the wilds of Carolina."

Governor Robert Johnson was captivated by the remarkable tale of the two weary captains. But Captain Palmer had not yet told the most shocking part of the story. He had recognized the captain of the *Revenge*, and his name was not Edwards—it was Stede Bonnet. Like Palmer, Stede Bonnet was from Barbados, and Palmer's sloop had been burned to ensure that the extraordinary news of Bonnet's life as a pirate did not reach his island home.

Stede Bonnet was born in 1688 near the capital of Bridgetown, Barbados, in the parish of Christ Church. He was the fourth generation of the Bonnet family to live on the English island colony. His great-grandfather had been among the first wave of English settlers to come to Barbados to carve sugarcane plantations out of the dense jungle. By the mid-seventeenth century, the profits of these huge, sprawling plantations had made Barbados the richest and most highly developed of all of England's colonies. At the time of Stede's birth, Barbados, which was only twenty-one miles at its widest, was crammed with nearly sixty thousand people. Nearly two-thirds of this population were slaves and indentured servants who worked the sweltering sugarcane fields.

The 1676 will of Stede's grandfather, Thomas Bonnet Sr., lists the Bonnet estate as including 520 acres, of which 120 acres were leased out to tenant farmers, and a town home on the prestigious High Street in Bridgetown. There were more than one hundred slaves and at least two windmills on the plantation that ground syrup from the cane. The Bonnet home was

An engraving of Stede Bonnet, the "Gentleman Pirate," from Captain Charles Johnson's *A General History of Pirates*.

staffed with a team of household servants who saw to all of the family's needs, and a stipend was set up to ensure that all of the children received liberal educations. Upon his death, the elder Thomas Bonnet bequeathed the majority of this property to Stede's father, Thomas Bonnet Jr.

Stede was born into a world of wealth and privilege and from his earliest years was groomed to take his place among the next generation of Barbadian gentleman planters. He shared this privileged life with two sisters, Frances and Sarah, who both also received a formal education—a rarity for girls in the early eighteenth century. The Bonnets were devoted members of St. Michael's Church in Bridgetown, and the Bonnet men traditionally served on the vestry.

Stede was only seven years old when his father was buried in the St. Michael's graveyard. His mother followed soon afterward, and records show that a Mr. John Gibbs gained guardianship of Stede and his sisters. However, by the time Stede was eleven years old, Jennet Whetstone, widow of former deputy secretary of Barbados John Whetstone, petitioned the council chamber to receive guardianship of the Bonnet children. The council granted Ms. Whetstone's request, and she seems to have played an important and motherly role in Stede's life until her death in 1708. By the time of her death, Stede had come of age and inherited his father's estate, taking his rightful place in Barbadian aristocracy.

In 1709, at St. Michael's, Stede married Mary Allamby, the eldest of six daughters of another leading Barbadian planter and member of the General Assembly, Colonel William Allamby, from the neighboring parish of St. Thomas. Colonel Allamby paid Stede a dowry of further sugarcane acreage. A Barbados law passed in 1652 bestowed military rank on the landowning aristocracy based on acreage owned. The owner of a mere fifty acres could receive the rank of captain. With the consolidation of his own estate and the land received from Mary's father, Stede merited the rank and title of major. For nearly three centuries, historians have inaccurately recorded Stede as an army officer with military experience, but his title of major came purely from his vast landholdings.

Regarded by friends and neighbors as a "gentleman of good reputation...master of plentiful fortune and [with] the advantage of a liberal education," Stede was proud and relieved when Mary gave birth to a son, Allamby Bonnet, in May 1712. The birth of a male heir was of the upmost importance in the rigid class system of Barbadian society. However, Stede's joy would be short lived. Census records show that Allamby died within his first year. Stede seems to have been deeply affected by the loss of his first child. Mary would give birth to three more children—Edward, Stede Jr. and Mary—but Stede was unable to shake the depression following Allamby's death. By 1716, Stede was showing signs of mental health issues, and the same friends and neighbors who

had previously lavished him with praise now described Stede as suffering "from a disorder in his mind, which had been but too visible in him."

Marital issues were further stressing Stede's fragile psyche. In the 1724 *General History of Pirates*, Captain Charles Johnson describes Stede's difficulties with Mary as "occasioned by some discomforts he found in a married state." Mary appears to have had a propensity for nagging her husband. As an escape, Stede turned to reading books. A voracious reader, Stede's home contained a well-stocked personal library. By the time of the birth of his last child, Stede had developed a passion for reading about nautical matters, including ship armaments, navigation and seamanship. Although Stede lived near Barbados's only port in Bridgetown, he had no maritime background. Captain Johnson described Stede as "ill qualified for the business, as not understanding maritime affairs." Stede was soon consumed by romantic tales of the pirates who were running rampant through the Caribbean. Books and newspaper reports on pirate activities were hugely popular reading in the early eighteenth century, and Stede developed a passion for following their exploits. He daydreamed of leaving behind his mundane plantation life and his nagging wife for a life of adventure on the seas.

In early 1717, much to the surprise and confusion of his family and friends, Stede commissioned a shipyard in Bridgetown to build a sixty-ton Bermuda-style sloop. A fast and nimble vessel, the Bermuda-style sloop was single-masted with a simple fore- and aft-rigged sail configuration—a large main mast aft and a smaller foresail. Popular with pirates because of its maneuverability and shallow draft, the sloop could escape into rivers and inlets not accessible to pursuing vessels that were larger and deep drafted. Although compact in design, the sloop was still sturdy enough to carry a hefty complement of cannons. Stede's sloop would boast an armament of ten guns. The shipyard did receive a strange request for one addition in the construction of Stede's sloop—extensive shelving installed in the great cabin for a library.

To his dumbfounded wife, Stede explained that his plans were purely for financial gain for the family. He would sail to Jamaica and obtain a privateer commission to hunt for the pirates he had obsessively been studying and reading about for the past few years. The capture of just one treasure-laden pirate ship would bring enormous rewards to the Bonnets. As outlandish as Stede's plan may have seemed to Mary, she would have found the truth inconceivable: Stede was planning to become a pirate.

Stede had secretly been recruiting a pirate crew in the taverns along Bridgetown's waterfront. Already defying pirate tradition by purchasing a ship

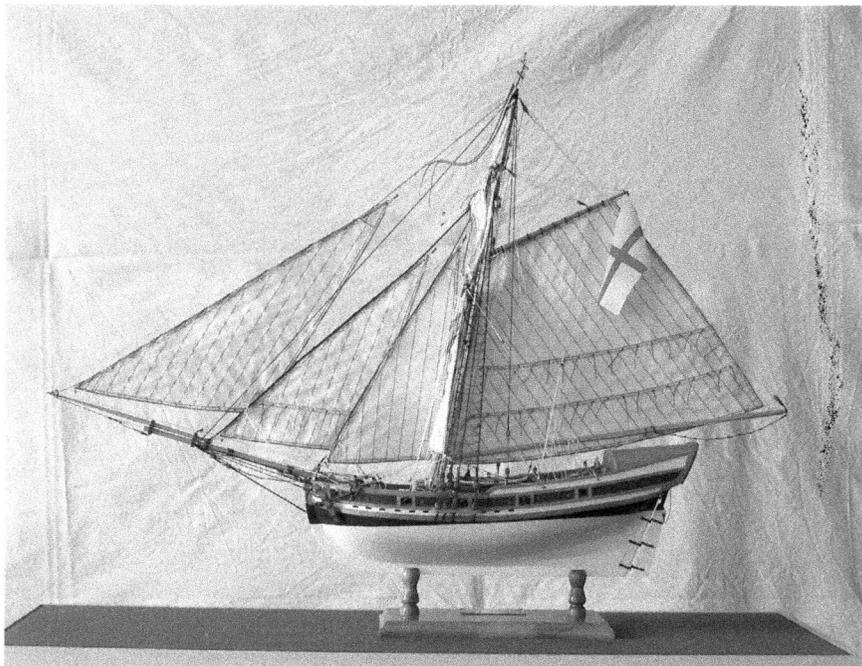

A model of an eighteenth-century Bermuda sloop. The maneuverable, shallow-drafted vessel with its simple fore- and aft-rigged sail configuration was popular with pirates.

rather than stealing one, Stede further broke with convention by paying his crew a salary rather than offering crew members shares of plunder. Lacking any practical maritime experience, Stede would have to pay his crew well, as he would be almost completely reliant on their skills once at sea.

Stede even patched together his own pirate flag. The English pirates referred to their flags collectively as the "Jolly Roger." Earlier French pirates, or buccaneers, had flown a blood red banner that was called the *Jolie Rouge* or "Pretty Red." An all-red flag had a tradition in naval warfare for being the signal to an enemy of "no quarter"—a veritable fight to the death. The English pirates had corrupted Jolie Rouge into Jolly Roger. The majority of the pirate flags of the Golden Age of Piracy were black with either a skull and crossbones or a skeleton at the center, accented with images of daggers, spears and hearts illustrating a pirate's violent intentions. Some flags also displayed an hourglass, which symbolized the short lives of those who chose to resist.

On a clear May night in 1717, without bidding farewell to his wife or children, Stede and seventy pirates boarded the newly constructed sloop,

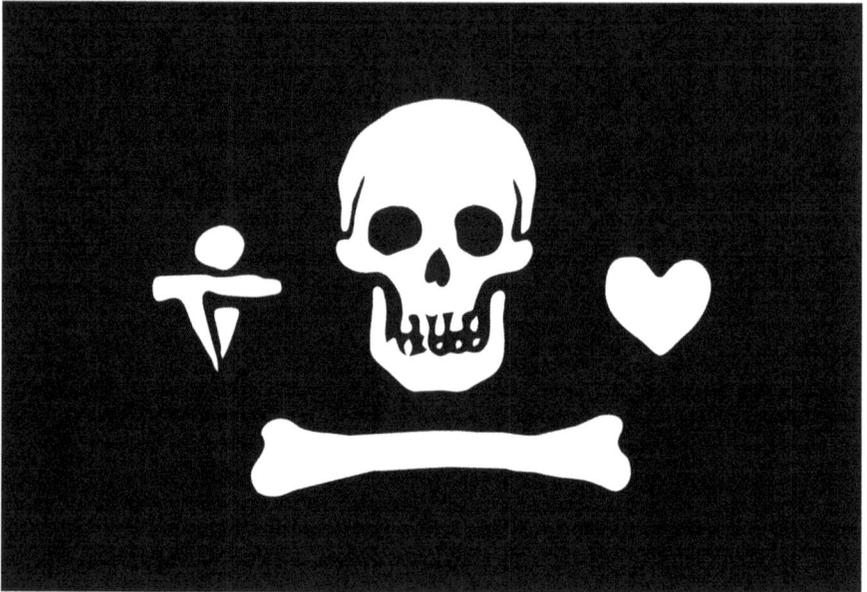

Stede Bonnet's flag. The various flags of the English pirates were collectively referred to as the "Jolly Roger."

christened *Revenge*, and slipped quietly out of Carlisle Bay. Standing on the quarterdeck, in stark contrast to his crew in his silk cravat, knee britches and powdered wig, Stede looked back at the moonlit sugarcane fields that stretched across the island. He would never see Barbados or his family again. Anxious to leave his former life as far behind as possible, Stede gave orders for the *Revenge* to set a course for the coast of Virginia, more than two thousand miles away. Instructions were given to the crew that their new captain was no longer to be called Major Bonnet but rather to be referred to as Captain Edwards.

Arriving off the busy shipping lanes of Virginia in June 1717, the new pirates found initial success, capturing the *Anne* from Glasgow, Scotland, commanded by Captain Montgomery. Two more prizes quickly followed, the *Young*, also from Scotland, and then the *Endeavor* from Bristol, England. The three vessels were stripped of their valuables, including clothes, money and ammunition. However, the capture of the *Turbet* a couple days later presented Stede with a dilemma. The *Turbet* was from Barbados, and the detained crew was not fooled by the man calling himself Captain Edwards. Stede's fellow Barbadians must have been shocked to see the former wealthy planter now in command of a pirate sloop. Determined not to let his secret

be carried back to Barbados, Stede ordered the *Turbet*'s crew transferred to one of the other captured prizes, and just as would be the fate of Captain Palmer's sloop in Charleston two months later, the *Turbet* was set on fire.

Steering north to New York, a sloop was captured off Long Island that offered little plunder. With provisions on the *Revenge* running low, a small group of pirates was landed at Gardiner Island to procure a list of needed items from the island's inhabitants. Stede, who was still not completely comfortable with his role as pirate captain, gave money to the landing party to buy the needed items from the locals rather than pillaging the coastal village. Over the next few weeks, as the *Revenge* sailed south, morale among the pirates slumped. Comments about Stede's shortcomings as master of the *Revenge* that had been previously only whispered among the crew were now lodged directly and openly at the captain. Many of the crew felt that what little success the pirates had found so far had been in spite of, and not because of, Stede's leadership. His ignorance of most things regarding the command of a ship were described as Stede being "obliged to yield to many things that were imposed on him, during their undertaking, for want of a competent knowledge in maritime affairs."

On any other pirate ship, a vote of confidence would be held by the crew, and a weak captain like Stede would be removed. However, the bizarre arrangement of a salaried crew and a ship that was solely owned by the captain left Stede with an uneasy dictatorship over the *Revenge*. Stede reacted to his crew's dissatisfaction by meting out punishment for even the smallest infractions. The crew grew even more demoralized, and by the time the *Revenge* appeared off Charleston in August and captured Palmer's and Porter's ships, there was mutinous talk among the pirate crew. When the *Revenge* completed careening in the Cape Fear River, Stede was anxious to capture a valuable prize, convinced that it would relieve the tension between captain and crew.

Passing near the Spanish wrecks, the *Revenge* steered southwesterly and bucked against the strong current of the Florida Straits. Stede knew that there were no waters richer with potential prizes than the windswept span between Florida and Cuba. A sail was soon spotted, and the eager Stede gave the order to pursue. A crew member along the railing was the first to identify that the vessel was not a merchantman but a Spanish man-of-war. Most likely sent from Cuba to patrol the Spanish wrecks, the man-of-war overwhelmingly outmatched and outgunned the pirate sloop—a fact that everyone onboard the *Revenge* seemed to know, except Stede. Determined to assert his authority, Stede curtly overruled any of the crew's objections or

suggestions of retreat and ordered the *Revenge*'s guns run out. The Spanish warship quickly recognized the pirates' intentions and maneuvered onto the approaching *Revenge*'s vulnerable stern. Before the pirates could tack and train their cannons on the enemy, the Spanish guns erupted, raking the *Revenge* from stern to bow. Hotshot screamed through the windows of Stede's great cabin and into the bowels of the sloop, tearing through bodies and bulkheads. Swinging onto the *Revenge*'s port side, the Spanish guns fired again. The broadside decimated the stunned pirates on deck. Stede stumbled unconscious onto the deck, his clothes bloodied from the splinters of wood lodged in his body. The *Revenge* was able to escape, but not before nearly half of the crew was killed. With their captain lying gravely wounded in his shattered cabin, the surviving pirates set a course for the safety of nearby Nassau.

Once anchored in Nassau Harbor, those pirates who had the strength deserted to the waterfront taverns and brothels. Stede was left without a crew and with a badly damaged *Revenge*. Certain that his pirate career was over, Stede was languishing in his cabin, his body racked with pain from his wounds, when he received a visitor who would change the course of his life. The visitor introduced himself as Edward Teach, but Stede recognized him immediately from descriptions he had read while still in Barbados. The tall man with the thick, bushy, dark beard braided and tied with ribbons was the era's most infamous pirate: Blackbeard.

Blackbeard entered into the piracy trade in the traditional way. He had served on a privateer out of Jamaica during Queen Anne's War. After the war, like many other former privateers, Blackbeard found his way to Nassau, signing on as first mate on the pirate vessel *Benjamin*, narcissistically named after its captain, Benjamin Hornigold. Hornigold was one of the eldest and most respected pirates operating out of Nassau. Shortly after Blackbeard signed on, Hornigold would join forces and sail in consortium with "Black" Sam Bellamy and a French pirate named La Bouche. The three captains formed a hugely successful pirate armada that hunted the waters around the Bahamas and Cuba. The circumstances proved the perfect pirate apprenticeship for Blackbeard. Among the most important lessons that he learned was the role of psychological warfare in piracy. Blackbeard's hulking body and thick beard were already menacing enough, but at times of battle, Blackbeard would enhance his frightening image by tucking fuses made of hemp cord under the brim of his hat. Dipped in a solution of saltpeter and limewater, these fuses would burn very slowly when lit, curling thick wisps of smoke around his face and creating a demon-like visage. Even among his

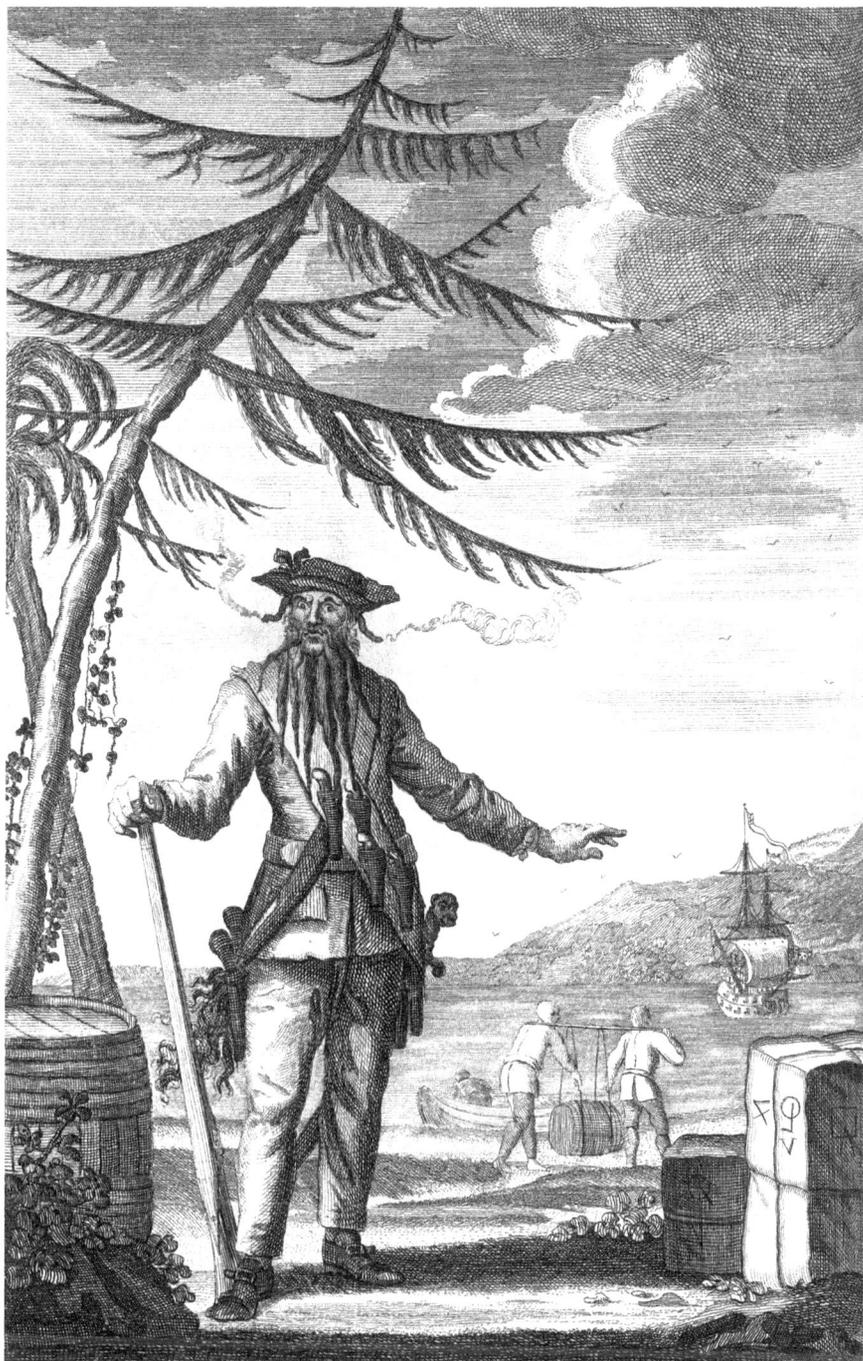

The infamous Edward Teach, aka Blackbeard. Note the slow-burning fuses protruding from under his hat, which gave Blackbeard a frightening devil-like appearance.

own crew, Blackbeard cultivated a fearsome reputation. Captain Johnson describes one of Blackbeard's devilish acts:

> *For being one day at sea, and little flushed with drink, "Come," says he, "let us make a hell of our own, and try how long we can bear it." Accordingly he, with two or three others, went down into the hold, and closing up the hatches, filled several pots full of brimstone and other combustible matter, and set it on fire, and so continued until they were almost suffocated, when some of the men cried out for air. At length, he opened the hatches, not a little pleased that he had held out the longest.*

By early 1717, Blackbeard had been given command of his own vessel. In March of that year, a letter was received in London from South Carolina governor Robert Daniell (Robert Johnson's predecessor) regarding the growing pirate threat in Nassau, which stated, "Five pirates made ye harbour of Providence their place of rendezvous vizt. Hornigold, a sloop with 10 guns and about 80 men; Jennings, a sloop with 10 guns and 100 men; Burgiss, a sloop with 8 guns and about 80 men; White, in a small vessel with 30 men and small arms; Thatch, a sloop 6 guns and about 70 men."

Shortly before Stede's ignominious arrival in Nassau in September 1717, Benjamin Hornigold had decided to retire from piracy. By the following year, he had accepted a government commission to hunt down his former pirate brethren. However, in 1719, while sailing across the Gulf of Mexico, Hornigold was drowned when his ship wrecked on a reef during a hurricane. Unlike his former mentor, Blackbeard had no plans to leave the pirate life behind, and now in command of a growing pirate crew, he was in the market for a new flagship. The damaged *Revenge* and her equally damaged captain resting at anchor in Nassau Harbor presented Blackbeard with a decided opportunity.

Blackbeard made Stede an offer that he could not refuse. The two pirates would form a most unlikely partnership. Blackbeard would repair and refit the *Revenge*, adding two more cannons, bringing the total to twelve. He would replace Stede's dead and deserted crew with members of his gang of more than 150 pirates. And finally, Blackbeard would assume command of the *Revenge* until Stede recovered from his appreciable wounds. Blackbeard's lieutenant, Richards, would be promoted to master of Blackbeard's smaller six-gun sloop. Blackbeard diplomatically described how he envisioned the Barbadian planter's new role on the *Revenge*: "As he [Stede] had not been used to the fatigues and care of such a post, it would be better for him to

decline it and live easy, at his pleasure, in such a ship as his, where he should not be obliged to perform duty, but follow his own inclinations." Stede readily agreed to Blackbeard's terms, and the two pirate ships set sail from Nassau in mid-September 1717, bound for America's eastern coast.

Off the coast of Virginia, the *Revenge* captured the *Betty*. Virginia's lieutenant governor, Alexander Spotswood, described the attack in a letter to London:

On or about the 29th day of September in the Year Afforsaid [1717] in an Hostile manner with Force and Arms on the high seas near Cape Charles in this Colony within the Jurisdiction of the Admiralty of this Court attack & force a Sloop Calld the Betty of Virginia...and the said Sloop did then and there Rob and plunder of Certain Pipes of Medera Wine and other Goods and Merchandise.

Off the coast of New England, the pirates captured a merchant vessel under the command of a Captain Codd. A 1719 issue of the *Boston News Letter* carried the story of the unfortunate Captain Codd "from Liverpool and Dublin with 150 Passengers, many whereof are Servants. He was taken 12 days since off our Cape by a Pirate Sloop called *Revenge*, of 12 guns, 150 Men, Commanded by one Teach, who Formerly Sail'd Mate out of this Port." Emboldened and high on the wine stolen from the *Betty*, the pirates "threw all Codd's Cargo over board, excepting some small matters they fancied."

Recovered from his wounds, the hapless Stede Bonnet was quickly learning that Blackbeard had duped him. It had become clear that Blackbeard had no intentions of returning command of the *Revenge* to her former captain. The *Boston News Letter* outlines Stede's diminished role on the *Revenge* in an article describing the attack on a vessel under the command of a Captain Goelet from Curacao bound for Philadelphia. The article chronicles how the pirates not only stole the crew's personal possessions but also wantonly threw the ship's cargo of cocoa into the ocean. The article further states, "On board the Pirate Sloop is Major Bennet [Bonnet], but has no command, he walks about in his Morning Gown, and then to his Books, of which he has a good Library on Board."

Several more ships, including vessels from St. Lucia, Antigua and New York, were plundered off the New England coast before the pirates decided to head south back into the Caribbean. In mid-November, a large two-hundred-ton, sixteen-gun slave ship from Nantes, France, was spotted off Martinique.

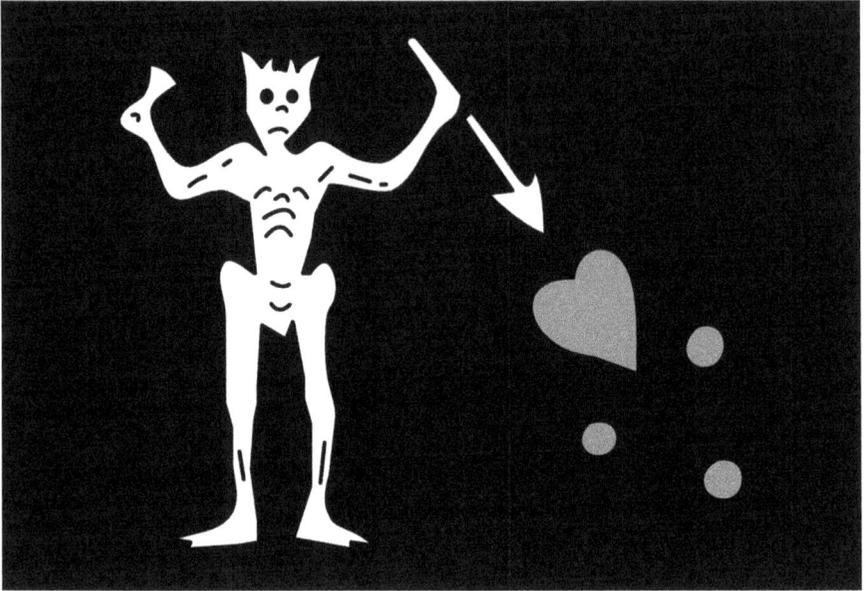

Blackbeard's flag.

Named *La Concorde*, the slave ship was just completing a transatlantic journey carrying more than four hundred slaves to the French colony at Martinique. The crew was suffering from dysentery and scurvy, and only half the crew was healthy enough for active duty. Although *La Concorde* outgunned the *Revenge*, the French slaver's crew was in no condition to put up a defense and quickly struck its colors and surrendered. Blackbeard decided to keep the robust *La Concorde* and convert the captured ship into his new flagship. *La Concorde*'s crew and cargo of slaves were put ashore on the nearby remote island of Bequia. Additional guns were added to the French ship, bringing her total to as many as forty cannons, and Blackbeard renamed his new flagship *Queen Anne's Revenge*, in honor of his former days fighting the French and Spanish as a privateer.

Stede was unexpectedly and unceremoniously given back command of the *Revenge*—but only briefly. Cruising in the Bay of Honduras, the *Revenge* and *Queen Anne's Revenge* separated to cover more ground. Sailing south to the Bay Islands, the twenty-six-gun, four-hundred-ton merchant ship *Protestant Caesar* from Boston was spotted near Roatan Island. Anxious to prove his mettle, Stede ordered an attack on the huge vessel just as the sun was setting. A broadside from the *Revenge* was answered in kind by heavy cannon fire from the *Protestant Caesar*. Exchanging deadly fire,

the two vessels maneuvered so closely to each other that small arms fire erupted, and Stede was able to call out to the *Protestant Caesar*'s captain, William Wyer, pacing his quarterdeck. Stede threatened that if the Boston merchant fired again on the *Revenge*, no quarter would be given. Unimpressed, Captain Wyer ordered another broadside fired. The two vessels engaged in a running fight for hours under the moonlight until the exhausted pirates finally broke off the pursuit and returned north to rendezvous with Blackbeard. Finding the *Queen Anne's Revenge* anchored at Turneffe, the *Revenge*'s crew reported to Blackbeard of the failed attack on the *Protestant Caesar*. A disappointed Blackbeard declared Stede's decision to attack the superior merchantman foolish and removed him from command of the *Revenge*. Stede was banished to the below decks of the flagship and held as a veritable prisoner on the *Queen Anne's Revenge*.

As Blackbeard was preparing to set sail, the unfortunate logwood cutting vessel *Adventure* sailed into the lagoon at Turneffe to take on fresh water. The *Adventure* was quickly captured, and Blackbeard decided to add the sloop to his growing armada. The *Adventure*'s captain, David Herriot, and most of his crew decided to join the *Queen Anne's Revenge*'s company rather than be left ashore at Turneffe. Blackbeard placed his trusted lieutenant, Israel Hands, in command of the *Adventure*. Arriving off Honduras on April 8, the pirates found the *Protestant Caesar* at anchor, making repairs after their battle with the *Revenge*. The spirit and boldness that Captain Wyer and his crew had displayed against the twelve-gun *Revenge* was lost when confronted with the forty-gun *Queen Anne's Revenge*. Wyer and his crew quickly lowered their longboats into the water and beat a hasty retreat to the safety of the jungle beyond the beach. Hidden in the mangroves, the *Protestant Caesar*'s crew watched as the pirates picked their vessel clean. Blackbeard sent a message to Captain Wyer, stating that if he would come aboard the pirate flagship for a meeting, no harm would come to him or his crew. A terrified Wyer came aboard the *Queen Anne's Revenge* and entered the great cabin of the captain. Blackbeard explained that he would honor his promise not to harm Captain Wyer or his crew, but the *Protestant Caesar* would have to be burned. Safely back on the beach, Wyer and his crew watched the pirate flotilla sail away as their ship burned to the waterline.

Sailing east and back across the Gulf of Mexico, Stede found a sympathetic friend in David Herriot, the former captain of the captured *Adventure*, both men now serving as reluctant members of the *Queen Anne's Revenge*'s crew. With the addition of the *Adventure* and her crew, Blackbeard's fleet had grown to four ships and over four hundred pirates.

A meeting of all the pirates was called on the deck of the *Queen Anne's Revenge* to determine the next course of action. Opinions varied; many wanted to return to Nassau, while others called for a return to the sugar-rich Windward Islands in the southern Caribbean. Suddenly, a soft, meek voice called out "Charleston!" It was Stede. Still determined to prove his worth and regain at least a little lost glory, Stede told the assembled pirates of his success eight months earlier when he was in command of the *Revenge* and had easily captured Captain Palmer's and Captain Porter's ships. Stede described the harbor's weak defenses, lack of a royal naval presence and the countless inlets and rivers that surrounded Charleston, where a pirate could hide. A vote was taken, and the decision was unanimous.

In late May 1718, Blackbeard's pirate armada appeared outside Charleston Harbor.

CHAPTER 4
Blockade

Captain Marks wearily shuffled out of his tiny cottage and into the shade of sail canvas stretched between four uneven posts. Remnants of cedar logs still smoldered in a fire pit. The previous night's fire had served in some small measure to ward off the mosquitoes and other biting insects that infested Sullivan's Island. Marks bellowed a long yawn and made his way toward the dunes that separated him from the ocean. Trudging halfway up the nearest sand bank, Marks gauged the wind before relieving himself on the sand-swept brush. Instinctively casting his eyes seaward, Marks abruptly stopped urinating when he saw the four ships lying between the two main channels leading into Charleston Harbor.

Marks was a Charleston harbor pilot, tasked with the job of guiding vessels over the treacherous sand bar that separated the open ocean from Charleston Harbor and then through the narrow channel that led to the city's wharfs. He would serve for up to a month at a time on lonely, desolate Sullivan's Island before being relieved to enjoy a few weeks' liberty back in the city. A small boat was maintained near the pilot's cottage to convey pilots to meet arriving vessels. Marks passed the long hours, and sometimes days, between newly arrived ships by playing cards and fishing with the pilot's mate, with whom he shared the tight quarters of the cottage.

Ships would normally fire one of their smaller rail-mounted guns to signal the request for a pilot, so it seemed strange to Marks that he had heard nothing from the four ships looming offshore. Even stranger was their position. Two channels led into the inner harbor—the northbound channel

that ran close to Sullivan's Island and the larger southbound channel, called Pumpkin Hill, that ran parallel to the beach of Morris Island. At night, crude "fier balls" made of tar and pitch burned in iron-cask baskets on the beaches of both islands to mark Charleston's entrance from the sea. Marks was surprised to see these four curious ships anchored directly between the two channels. Calling for his mate still slumbering in the cottage, Marks walked down to the beach to prepare the pilot boat.

Tacking against the westerly breeze, Marks manned the rudder while his mate trimmed the sails of the pilot boat. Drawing near the four ships, Marks could see the large number of cannons that the visiting vessels carried. The largest of the four ships carried a particularly huge arsenal of guns, and Marks assumed that it must be a royal naval ship. It had been more than a year since the warship *Shoreham* had departed from Charleston despite the protests of the city's authorities. Marks hoped that perhaps the requests to the Lord Proprietors for another warship to be stationed in the harbor had finally been realized. Marks dropped the sails as the pilot boat slipped into the lee of the largest ship. Mounting the Jacob's ladder, he clambered over the rail and onto the deck, where he was stunned to be met by a mass of pirates with weapons drawn. Blackbeard grinned at Marks and welcomed him onboard the *Queen Anne's Revenge*.

Marks's pilot boat would be the first of nine vessels that would be captured over the course of a couple days. News of the pirate armada and its growing collection of prizes soon reached the panicked city, and commerce was paralyzed as no ship dared to sail out of the harbor. Among Blackbeard's prizes was the *Crowley*, commanded by Captain Robert Clark. The *Crowley* was not laden with goods or treasure. She carried an even more valuable cargo for Blackbeard: passengers. These passengers were some of Charleston's wealthiest and most influential citizens who had waited for the ease in weather that came with the springtime before making the long ocean journey to England. Most notable among the *Crowley*'s passengers was Samuel Wragg, a wealthy merchant and member of the Carolina Provincial Council. Wragg was traveling to London, accompanied by his young son, William, to meet with the Lord Proprietors to personally request financial and defensive support for the city. William was only four years old when the *Crowley* was seized by the pirates, but in time he would become one of the most influential men in the American colonies. In his 1894 book *The Carolina Pirates and Colonial Commerce*, Shirley Carter Hughson briefly describes William Wragg's remarkable life and tragic death:

He [William Wragg] *was educated in England, and held many responsible public positions in South Carolina during the period just prior to the Revolution. In 1771 he was tendered the Chief Justiceship of the Province, which he declined. He was a devoted loyalist during the struggle for independence, but such was his character that he retained the highest esteem for his fellow-countrymen. Foreseeing the success of the*

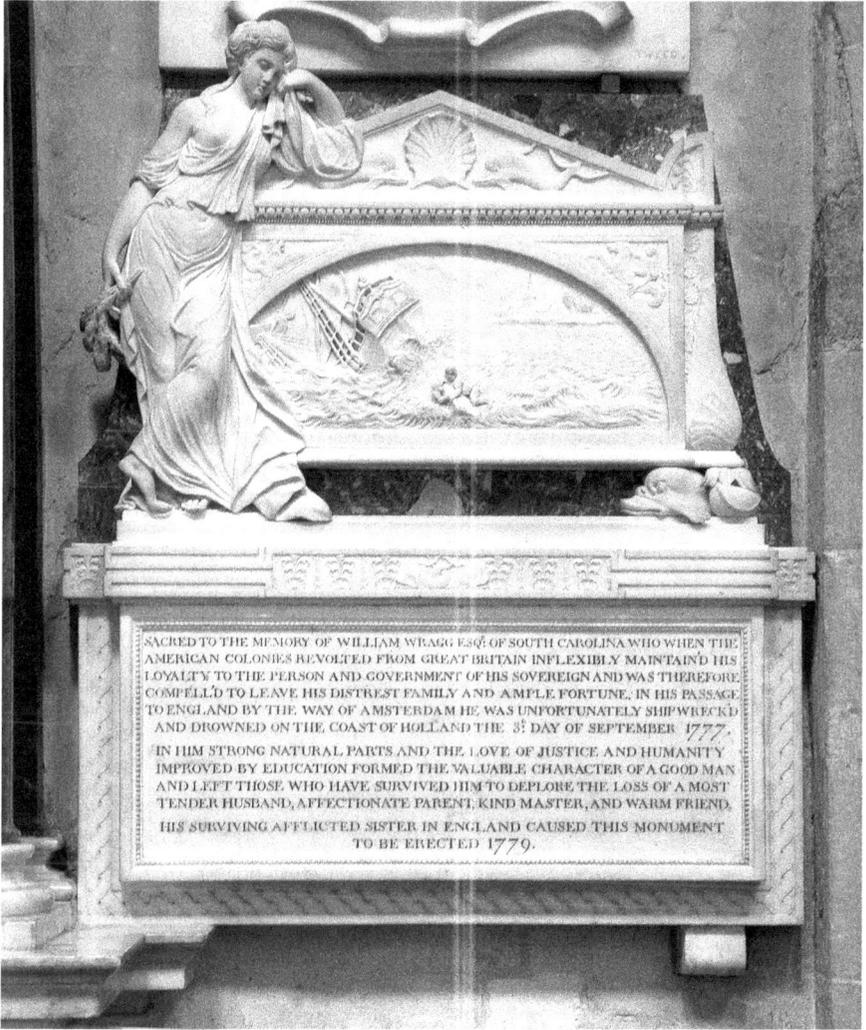

The William Wragg monument at Westminster Abbey, London. Erected in 1779, the monument depicts the scene of Wragg's tragic drowning off the coast of Holland after his flight from Charleston. *Copyright Dean and Chapter of Westminster.*

American arms, he disposed of his Carolina estates and in 1777 sailed for England. His vessel was lost on the coast of Holland in September of that year, and he was drowned with the entire crew. Such was the regard in which he was held that George III had a memorial erected in Westminster Abbey in his honor.

The passengers of the *Crowley* were taken on board the *Queen Anne's Revenge* to be interrogated. Blackbeard was quick to recognize the value of his new hostages, particularly that of Samuel Wragg and his son. Blackbeard dismissed the frightened passengers after their questioning, and they were all returned to the *Crowley*, where they were thrown into the dark, steamy hold of the ship. While the captives comforted one another, fearing death at any moment, a council meeting was held by the pirates on the deck of the *Queen Anne's Revenge*. An hour later, the hatch cover was abruptly removed, and the *Crowley's* passengers were shuffled back to Blackbeard's flagship.

Blackbeard informed the hostages that the pirates had unanimously voted to send a delegation of pirates, including Blackbeard's lieutenant, Richards, into Charleston to deliver a list of demands to Governor Robert Johnson. (Accounts differ on exactly how many pirates were sent into the city. Most stories describe only two pirates, but in later trial transcripts, Nicholas Trott and Attorney General Richard Allein detail as many as five pirates delivering the ransom to the governor.) Blackbeard explained to the hostages that in order to ensure delivery of their ransom and the safe return of the messengers, all of the *Crowley's* passengers would be held hostage on the *Queen Anne's Revenge*. Further, if there were any treachery by the governor, all of the hostages would be put to death and their severed heads sent back to the city.

Presenting himself as the spokesperson for the hostages, Samuel Wragg boldly addressed Blackbeard:

> *He proposed that one of them might go with the two gentlemen that were to be sent on the embassy, who might truly represent the danger they were in, and induce them more readily to submit, in order to save the lives of so many of the King's subjects, and further, to prevent any insult from the common people (for whose conduct on such an occasion, they could not answer) on the person of his envoys.*

Wragg offered to personally accompany the pirates into the city, leaving his son behind on the *Queen Anne's Revenge* as a sign of good faith. However, Blackbeard was not willing to release his most valuable prisoner, and

Captain Marks was chosen instead. As the longboat was lowered into the water, Blackbeard explained to Marks that he had exactly two days to return with the ransom. Blackbeard warned Marks that if he failed in his mission, the *Queen Anne's Revenge* would "come over the barr for to burn the ships that lay before the Towne, and to beat it about [its] ears." Burdened with the heavy weight of his charge, Captain Marks stood in the bow of the longboat and gave the heading for the familiar course across the bar and into the harbor. Massing along the rail, the desperate hostages watched

This Lean, Straight Rover Looked the Part of a Competent Soldier, by Frank Schoonover, offers an exaggerated depiction of Blackbeard's pirates marching through the streets of Charleston during the blockade of 1718.

Marks and the pirate envoy fade into the setting sun.

When two days passed without any news from Marks or his pirate companions, Blackbeard was furious. It seemed clear that the governor must not value the lives of the city's captive citizens. Richards and the pirates ashore had certainly been arrested and faced the noose. Blackbeard called the hostages on deck and instructed them to make their peace with God and prepare for immediate death. Samuel Wragg interrupted the ranting Blackbeard and suggested that there must be some unforeseen reason for the delay. He proposed that perhaps the governor was having difficulty locating all of the items on the ransom list and more time was needed. Ever the politician, Wragg was able to placate Blackbeard, if only temporarily. One more day was given for the ransom to be delivered.

Late in the afternoon of the following day, a small boat was seen coming out of the harbor. The hostages' hopes of salvation were dashed when it became clear that the boat contained neither the ransom nor Marks and the pirates. The boat was manned by a fisherman who explained that he had

been paid by Captain Marks to deliver a message to Blackbeard explaining the ransom's delay. The fisherman described how Marks and the pirates had been caught in a sudden squall on the way into the harbor, and their boat had capsized. The men swam to an uninhabited island several miles from Charleston. Aware of the deadly consequences of delay, the pirates

> set Mr. Marks on a hatch and floated it upon the sea, after which they stripped and flung themselves in, and swimming after it, thrust the float forward, endeavoring by that means to get to town. This proved a tedious voiture and in all likelihood they would have perished, had not this fishing boat sailed by in the morning, and perceiving something in the water, made to it, and took them in, when they were near spent with their labor.

Blackbeard begrudgingly accepted the explanation and instructed the fisherman to return to the city and advise the governor that he had two more days to comply with the pirates' demands. The hostages, by now exhausted and numb with fear, returned below decks to await their uncertain fate.

Two more days passed without any news from the city, and Blackbeard paced the quarterdeck boiling with anger. The hostages were again called on deck and told to prepare to lose their heads. However, several spoke up and pledged their allegiance to the pirates, offering to pilot the pirate vessels into the harbor, and if the sight of the pirate armada did not entice the governor to deliver the ransom, "they would stand by [the pirates] to the last man." Blackbeard appreciated the notion of destroying the city with the help of its own citizens and ordered eight ships, his own four fighting ships and four of the prizes, to weigh anchor and move into the harbor.

The people of Charleston were terror stricken as the eight ships came into full view of the city. Militia scrambled to Granville Bastion and the Half Moon Battery to man the cannons as the *Queen Anne's Revenge* trained her guns on the city's walls. Men of all ages were hastily given arms to defend the city while "women and children ran about the streets like mad things." Merchant ships that had been trapped in the harbor for nearly a week recklessly cut their anchor lines and made a break for the open ocean. Just as Blackbeard was about to give the order for the first salvo to be fired by the portside guns, a small boat was seen coming from Rhett's Wharf. Rowed slowly into the chaos of the harbor, the boat held a man perched in the bow frantically waving a white scarf. It was Captain Marks. His pirate companions pulled lazily on the oars, seemingly oblivious to the near cataclysm surrounding them. Blackbeard ordered his men to hold their fire as the longboat came

alongside. The hostages, who only moments before were preparing to destroy their own city, gathered around the chest that was hauled on the deck of the *Queen Anne's Revenge*. Anxious to see the ransom that had nearly cost them their lives, all were shocked to see a chest, not of gold or silver, but instead full of medicine, particularly mercury.

It seemed that Blackbeard and many of his crew were suffering from venereal disease, most likely syphilis, probably acquired in the brothels of Nassau. Historian Addison Whipple speculated that Blackbeard, whom legend holds had as many as sixteen wives, "wanted the mercurial preparations in the chest because his most recent girl friend had not only married him but also left him with a venereal disease to remember her by." In the early eighteenth century, mercury—or quicksilver, as it was called— was used to treat a bevy of diseases. It was unknown to doctors of the time that the remedy was oftentimes more dangerous than the disease that was being treated. Contemporary accounts list the value of the contents of the medicine chest to be between £300 and £400 sterling. A paltry sum

The Old Exchange and Provost Dungeon in Charleston stands at the location of the Half Moon Battery and the Court of Guard building of the original walled city. *Photo courtesy of the Old Exchange and Provost Dungeon, 122 East Bay Street, Charleston.*

considering the terror and grief that Blackbeard's blockade wrought but evidence that some of the pirates must have been desperately ill.

Captain Marks detailed to the group assembled on the deck the circumstances for the ransom's second delay. Governor Johnson and his council immediately recognized that the city was in no condition to oppose the pirates, and all agreed to submit to the demands as they had "no wish to sacrifice the lives of valued citizens for a few dollars' worth of medicine." It had taken only a few hours to locate and acquire the contents for the medicine chest. Meanwhile, Richards and his pirate companions openly and insolently strutted the streets of Charleston within "the sight of all the people, who were fired with utmost indignation, looking upon them as robbers and murderers and particularly the authors of their wrongs and oppressions; but durst not so much think of executing their revenge, for fear of bringing more calamities upon themselves, and so they were forced to let the villains pass with impunity." However, when the chest was ready for delivery, Marks was unable to find the pirates. A general alarm called for all citizens to search for the pirates, but for nearly two days, there was no sign of them. Just moments before Blackbeard's ships arrived in the harbor, the missing pirates were finally discovered. Having taken full advantage of their shore leave, they were found gloriously drunk and unconscious in one of Charleston's taverns.

With receipt of the medicine chest, Blackbeard released the prizes and hostages, but not before the *Crowley*'s passengers were stripped of their clothes and possessions and returned to shore half-naked. Watching from the city's ramparts, the men and women of Charleston breathed a sigh of relief as the four pirate ships sailed out of the harbor.

Considered by many historians as the "high tide" of the Golden Age of Piracy, the blockade of Charleston would seal Blackbeard's passage into legend. However, the triumphant Blackbeard, possibly due in part to his illness, had decided to retire from piracy. As the *Queen Anne's Revenge* sailed north from Charleston, Blackbeard called Stede Bonnet into his cabin. Stede had been a quiet observer onboard the *Queen Anne's Revenge* during the blockade and was surprised to find himself called into the presence of the conquering Blackbeard. Ignoring any past sentiments of betrayal or coercion, a conciliatory Blackbeard offered Stede command of the *Revenge* and proposed a new partnership, but this time within the confines of the law. The king of Denmark had declared war on Spain and was enlisting privateers. Blackbeard suggested that he and Stede take advantage of King George's recent offer of pardon and then sail to Denmark's Caribbean colony

Pirates in Charleston depicts Blackbeard's pirate envoy carousing in one Charleston's taverns during the blockade of 1718.

of St. Thomas to receive privateer commissions. Stede pointed out that King George's "Act of Grace" extended to those acts of piracy committed before January 5, and their attacks on the *Protestant Caesar* and the *Adventure* in the Bay of Honduras, as well as their actions at Charleston, fell well outside the terms of the pardon. Blackbeard countered that with a simple gift of some of their accrued plunder, Charles Eden, the governor of the fledgling colony of North Carolina, would be willing to issue pardons to both Blackbeard and Stede. A course had been set for Topsail Inlet, just a short day's journey from North Carolina's capital at Bath on the Pamlico River.

A urethral syringe recovered from the wreck of the *Queen Anne's Revenge*. Filled with mercury procured at the blockade of Charleston, the syringe was used by Blackbeard and his crew to treat venereal disease. First discovered in 1996 near Beaufort, North Carolina, excavation operations of Blackbeard's ship are still ongoing. *Photo courtesy of the North Carolina Department of Cultural Resources.*

Entering Topsail Inlet, Stede watched nervously as Blackbeard seemed to steer the *Queen Anne's Revenge* perilously close to the waves breaking on the sand bar that hemmed the beach. Blackbeard had previously proven himself a consummate navigator, but as the consort of pirate ships prepared to follow the *Queen Anne's Revenge*'s lead through the narrow passage into the safety of the anchorage, the sails fell slack as the flagship heeled violently. The *Queen Anne's Revenge* had run hard aground on a sand bar. Blackbeard called out to Israel Hands at the helm of the *Adventure* to throw over lines to haul the beached ship off the sand, but it was too late. As the waves drove the massive ship further on her side, it became clear that the *Queen Anne's Revenge* was lost.

Blackbeard encouraged Stede to begin the journey inland to the governor's home to obtain his pardon. Blackbeard would briefly stay at Topsail Inlet and supervise the salvage of the *Queen Anne's Revenge*, but he assured Stede that he would shortly follow him to Bath, and then the two could set a course for St. Thomas and their new privateering partnership. A longboat was loaded with sugar and molasses to serve as a bribe for the governor, and Stede and several other pirates began their journey up the Core Sound toward Bath. Stede would never see Blackbeard again.

Back in Charleston, in the wake of the blockade, the citizenry was pressuring Governor Johnson to take action against the pirates. Fear of the pirates had been replaced by anger and frustration. Nicholas Trott expressed the city's sentiment: "And indeed, the inhabitants of this Province have of late, to their great cost and damages, felt the evil of piracy, and the mischiefs and insults done by pirates." A letter from Governor Robert Johnson to the Commission of Trade in London, written in June shortly after the blockade, illustrates the sense of desperation and helplessness that permeated Charleston:

The unspeakable calamity this poor province suffers from pirates obliges me to inform your Lordships of it in order that his Majesty may know it and be induced to afford us the assistance of a frigate for to cruize [sic] hereabouts upon them, for we are continually alarm'd and our ships taken to the utter ruin of our trade, twice since my coming here in nine months time they have lain off of our bar taking and plundering ships that either go out or come in to this part, about fourteen days ago four sail of them appear'd in sight of the town, took our pilot boat, and afterward 8 or more sails with several of the best inhabitants of this place aboard and then sent the word if I did not immediately send them a chest of medicines, they would put any prisoners to Death, which for their sakes being comply'd with, after plundering them of all they had were sent ashore almost naked. This company is commanded by one Teach alias Blackbeard, has a ship of 40 good guns under him and three sloops, tenders besides, and are in all above 400 men. I don't perceive his Majesty's gracious proclamation of pardon works any good act upon them, some few indeed surrender & takes a certificate of their so doing and then several of them return to the sport again…

Shortly after Johnson's letter was written, a pirate named Vaughn appeared outside the harbor. Following Blackbeard's model, Vaughn sent a letter into the city with a list of demands. Again impotent to resist, Governor Johnson had the ransom filled and delivered. The insult by Vaughn coming so close on the heels of Blackbeard's blockade proved too much to bear for the people of Charleston. The collective decision was made that if no help could be expected from England, then the people would have to take matters into their own hands.

CHAPTER 5
Pirate Hunter

William Rhett first arrived in Charleston in 1694, when he was twenty-eight years old. Serving as captain of the *Providence*, Rhett appears in a letter dated September 7, 1699, sent by Nicholas Trott to then governor Joseph Blake in Charleston, which instructs to collect from William Rhett "all such sums of money goods wares merchandise negro slaves, gold, elephants teeth wax effects and things whatsoever on account of their being part owners of the ship *Providence* burthen 150 tons, whereof the said William Rhett is commander." A man of fiery temper, Rhett would transcend his humble beginnings as a seaman and become one of the Carolina Province's most prolific leaders. Ambitious and enterprising, he would serve as commissioner of fortifications and Indian trade, receiver general of the province, deputy surveyor of customs, member of the assembly and, in 1712, speaker of the assembly. As a leader of the province's militia, he would earn the title Colonel William Rhett.

Brash and bullying like his friend Nicholas Trott, Rhett was not afraid to use intimidation and force to impose his will. In 1702, while Queen Anne's War was only in its second year, a force was sent from Charleston to attack the Spanish at St. Augustine. While initially successful, the English force lacked the needed artillery to hold the city, and when two Spanish frigates were dispatched from Havana to St. Augustine, the siege was abandoned and the expedition returned to Charleston. In May 1703, a measure was adopted by the assembly in Charleston, of which Rhett was a member, to impose a direct tax on real and personal estates to pay the £4,000 sterling debt incurred

from the failed expedition, including a twelve shilling tax "a head on every negro slave (children under eight years old excepted) imported from the West Indies, or any other place but Africa, and sold in the province; and ten shillings per head on all such imported from Africa." Many in the province who had been against the attack on St. Augustine were now incensed at the proposition of being taxed to pay for it. Among the most vocal was a wealthy merchant named John Ash. In a letter written in protest to the Lord Proprietors, William Rhett

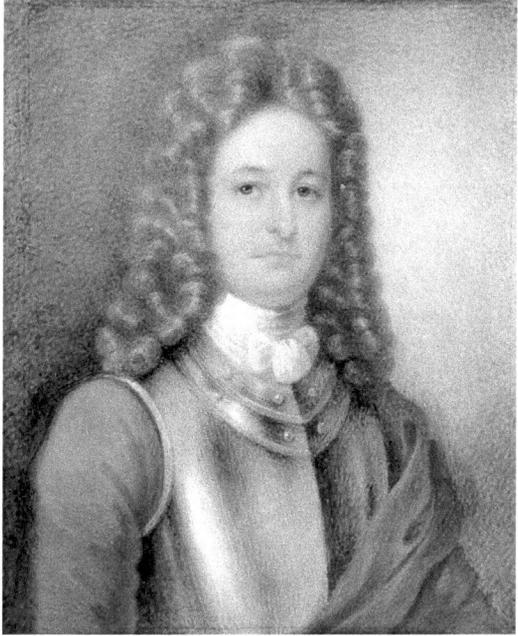

William Rhett.

was named as the ringleader of a mob that threatened and intimidated Ash for his objections to the tax:

> And that evening when he the said Ash was retired into a friends chamber for security the same armed multitude came to the House where the said Ash was & demanded him down assuring him at the same time that they would do him no hurt, but only wanted to discourse with him; upon which assurances he came down to them who notwithstand'g being encouraged and assisted by Captain Rhett & others drew him on board his the said Rhetts ship revilling him & threatening him as they dragged him along; and having gotten him on board the said Rhetts ship they sometimes told him they would carry him to Jamaica at other times they threatened to hang him or leave him on some remote island.

Rhett shared a contentious and volatile relationship with the string of proprietary governors who served during his lifetime. By 1712, Rhett had grown wealthy and owned an estate of twenty-eight acres, called Rhettsbury, outside the city walls. He also owned a home that fronted Bay Street, and

William Rhett's house at 54 Hasell Street, built circa 1712, is considered to be one of the oldest homes in Charleston. Located only a few blocks north of bustling Market Street in downtown Charleston, the house originally sat outside the city's northern wall on an estate called Rhettsbury that encompassed twenty-eight acres of land

extending from the city's northeastern wall, Rhett owned a large wharf that bore his name. His position as deputy surveyor of customs, while also being a merchant and owner of a large wharf, was considered by many to be a blatant conflict of interest. Rhett had been accused of abusing his government title by offering favors to vessels that used his wharf and services. This "conflict of interest" led to open hostilities in 1716 between Rhett and then governor Robert Daniell. Daniell had commissioned Captain Matthew Husson to hunt pirates around Florida and the Bahamas. When the prize *Betty* was brought by Husson into Charleston Harbor, a dispute of jurisdiction over the prize between Rhett and Governor Daniell exploded and divided the city. Rhett believed that as deputy surveyor of customs he should have access to the prize to ensure the Crown received its fair portion. Governor Daniell contested that the prize had come from his commission to Captain Husson and denied Rhett access to the vessel under threat of arrest. Rhett ignored Daniell's threats and boarded the *Betty*, loading confiscated goods into his longboat to deliver to his wharf. Enraged, Daniell called out the militia.

Seeking protection, Rhett steered his longboat toward the Royal Navy warship HMS *Shoreham* anchored in the harbor. Daniell called for Rhett to return with the *Betty*'s cargo, but Rhett ignored him. Daniell ordered the militia to open fire, and Rhett was struck in the chest. And while the resilient Rhett would survive the wound and the *Betty*'s cargo was eventually returned to Daniell, the remainder of his term as governor was uneasy in the wake of the conflict with Rhett.

By the time of Governor Robert Johnson's arrival in Charleston in 1717, Rhett and Trott had taken full advantage of the weak authority of the proprietary government and asserted themselves as the leaders of the province. The two men shared a strange, adulatory relationship throughout their lives. Both men were active members of St. Philip's Church, and both donated large amounts of money for the construction of the second St. Philip's Church, completed in 1723 (construction of the current church was completed in 1836). When Rhett died on January 12, 1722, Trott courted Rhett's widow, Sarah, marrying her at St. Philip's on March 4, 1727. But

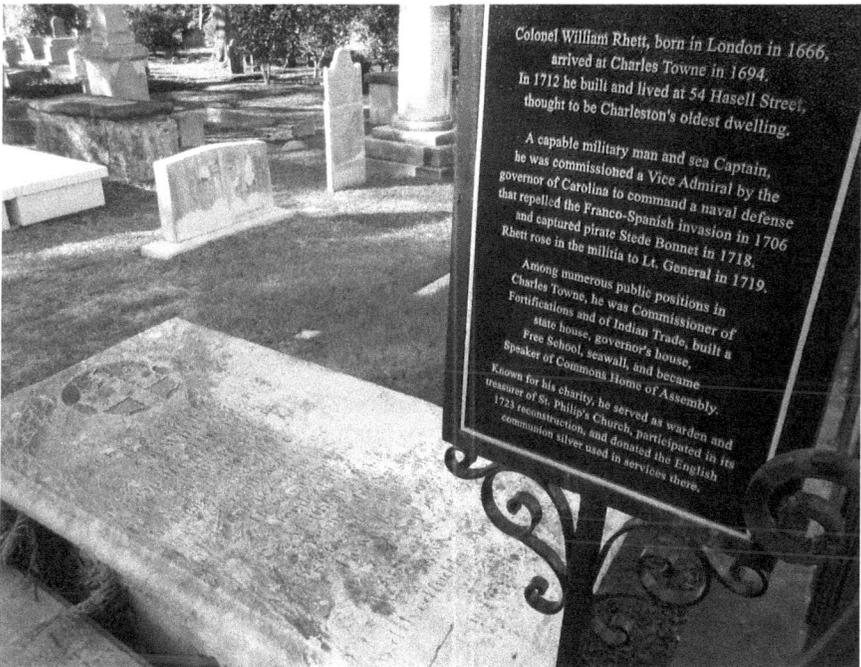

William Rhett's grave (d. 1722) at St. Philip's Church in Charleston. Nicholas Trott married Rhett's widow, Sarah, in 1727. Both Nicholas and Sarah lie in unmarked graves next to William Rhett.

while Trott was mistrusted, even hated, by many in the province, Rhett was considered a hero to the people. Whatever his transgressions and improprieties, Rhett's service to and defense of the colony won the hearts of the citizens and defined his legacy. It was Rhett who had commanded the fleet that repelled the combined French and Spanish invasion in 1706.

In late August 1718, news reached Charleston that a pirate ship with two prizes was lying in the Cape Fear River in North Carolina. A small vessel that had put in at Cape Fear only a couple weeks prior had been captured. The pirates released the captain and his crew but broke up their boat, using the timbers to repair their own pirate sloop. Charleston's populace, still stinging from the insults of Blackbeard and Vaughn, demanded that Governor Johnson take action against the pirate at Cape Fear, hoping that it might be Blackbeard himself. William Rhett submitted a plan to command an expedition to subdue the pirates lurking to the north. Governor Johnson endorsed the plan, and on September 10, the sloop *Henry* with eight cannons, commanded by Captain John Masters, and the *Sea Nymph*, also with eight cannons, commanded by Fayrer Hall, set sail from Charleston. Rhett sailed on the *Henry* and was in overall command of the expedition that totaled a combined force of 130 men. Crossing the harbor and dropping anchor off Sullivan's Island's western tip, the two ships took on fresh water and made final preparations. A small sloop was spotted approaching from the south, firing its signal gun. The sloop proved to be a merchant vessel from Antigua, commanded by a Captain Cook. Climbing onboard the *Henry*, Captain Cook promptly reported to Rhett that his ship had just been plundered off the Charleston bar by Charles Vane in a brigantine of twelve guns and ninety men. Vane was sailing in consort with another pirate sloop under the command of a pirate named Yeates.

Charles Vane had started his pirate career by diving the Spanish wrecks before becoming one of the founding members of the pirate colony at Nassau. Just a few weeks prior to his arrival in Charleston, Vane had been in Nassau when a new governor named Woodes Rogers arrived in Nassau Harbor with two heavily armed men-of-war. Woodes carried with him King George's offer of pardon, which was readily accepted by the majority of the pirates when presented with the show of force in the harbor. However, Vane had no intentions of leaving the piracy trade. Vane set one of his prizes on fire and launched it toward Rogers's warships. Cutting his anchor line and making a break for the sea, Vane fired shots at the new governor's ship as he slipped out of the harbor. Two days later, Vane expanded his pirate venture with the capture of a sloop from Barbados of which Yeates was given command.

Charles Vane.

Vane was prowling the Carolina coast, looking for Blackbeard to discuss forming a partnership and possibly an assault on Nassau and its new governor. Stopping off Charleston, Vane captured a ship from Ipswich, laden with logwood and under the command of a Captain Coggershall. Vane initially

decided to keep the prize for his own purposes and forced the crew to throw their cargo of timber overboard, but after more than half of the logwood had been jettisoned, Vane changed his mind and let the ship continue on its voyage. The capture of a sloop from Barbados commanded by a Captain Dill and a ship from Curacao commanded by a Captain Richards quickly followed. When a large brigantine from Guinea with ninety slaves onboard was seized, the human cargo was transferred to Yeates's sloop. However, Yeates seems to have had a change of heart in regards to his piratical occupation. Under the cover of night, Yeates quietly weighed anchor and sailed south, putting in at the Edisto River south of Charleston. With the memories of Blackbeard's and Vaughn's actions still fresh in their minds, panic once again gripped Charleston when a pirate envoy sent by Yeates arrived in the city asking for an audience with Governor Johnson. Fears abated when the pirates asked the governor if Yeates and the rest of his crew could turn over the ninety slaves and receive the king's pardon. Johnson happily agreed to the terms.

An infuriated Vane unsuccessfully searched for Yeates for several days before deciding to return to his hunt off Charleston. Four more vessels were captured, including two vessels bound for London, the *Neptune* and the *Emperor*, and the sloop of the unfortunate Captain Cook. Cook reported to Rhett that while Vane was plundering his ship, he had overheard some of the pirates discussing plans to put in at an inlet south of Charleston to careen their brigantine. On September 15, Rhett gave the order for the *Henry* and *Sea Nymph* to weigh anchor and sail south to search for Vane. However, Vane's crew had cleverly misinformed Captain Cook about their intentions. Vane had actually sailed north to continue his search for Blackbeard. After a few days, Rhett called off the search for Vane and set a course for the Cape Fear River. A strong northeasterly wind made progress slow, and the *Henry* and *Sea Nymph* did not arrive at the river's mouth until the afternoon of September 26.

Less than a mile upriver, hovering above the tree line, Rhett could see the masts of three ships. A pilot was signaled for, and once onboard, the *Henry* took the lead into the broad entrance of the river. Cape Fear was notorious for its narrow, shoaling channel, and even with an experienced pilot onboard, the *Henry* quickly ran aground. The *Sea Nymph*, following in her wake, also found the river bottom. While waiting for the high tide to float their stranded vessel, the crew of the *Henry* spotted three canoes approaching. It seemed the pirates had also seen the masts of Rhett's ships above the tree line and sent a group to investigate. The *Henry*'s crew demanded for the strangers to

Woodes Rogers, governor of the Bahamas. The painting shows the walls of the fort overlooking Nassau Harbor behind Rogers. The globe next to Rogers represents his circumnavigation during his privateering voyage, from 1708 to 1711.

surrender themselves, but the three canoes quickly retreated back upriver. With the pirates alerted to their presence, it was clear to Rhett and his men that the dawn would bring a fight.

Throughout the night, the crews of the *Henry* and *Sea Nymph* and the crew of the pirate ship could hear one another's frenzied preparations for battle. The sound of cannon carriages being winched and crews clearing decks carried over the still, open water. The *Henry* and *Sea Nymph* were refloated with the high tide, but the pirates still had the distinct advantage of knowing their enemy's number and armaments. Rhett and his men still had no idea how powerful of a force they faced.

As dawn broke, Rhett could see a sail being raised to the mast top of one of the enemy ships. The tide had just begun to ebb, and the pirates were trying to take advantage of the boosted current to run past the *Henry* and *Sea Nymph* and stand for the open sea. Rhett gave the order to weigh anchor as the pirate ship rounded the headland and came into full view. With the *Sea Nymph* waiting downstream in reserve, the *Henry* set a course to intercept the sloop now filling the tight channel that hugged the shoreline. As the *Henry*

closed the gap, the pirates steered closer to the edge of the channel until the sloop suddenly and violently heeled over on her starboard side. The pirates had run aground. Drawing to within one hundred feet of the sloop, the *Henry* also ran aground. The *Sea Nymph* was well out of range downstream but also found herself grounded on the river bottom.

With the extreme list of the grounded vessels, neither side could angle its cannons to fire on the other, but musket fire immediately erupted. The deck of the pirate sloop was leaning away from the *Henry*, and the pirates were able to find cover behind the railing. However, the *Henry*'s deck was fully exposed, and Rhett's men were decimated by deadly shot pouring down on them from the pirates. The two ships were positioned so close together that taunts and insults were exchanged across the narrow gap. A contemporary account of the battle described the action: "The pirates made a wiff in their bloody flag, and beckoned with their hats in derision to our people to come on board them; which they only answered with cheerful Huzza's, and told them it would soon be their turn." For five hours, the battle raged as men who dared to move from the safety of cover were struck down. The captain of the pirate ship called to Rhett and informed him that he would ignite his powder magazine and send them all to the bottom of the river before he would surrender. But regardless of bravado and threats, it was obvious to both Rhett's men and the pirates that the winner of the engagement, which would come to be called the Battle of the Sand Bars, would be the side whose vessel refloated first. As fate would have it, the *Henry* was the first to lift free from the sand, producing a great cheer from her crew.

As Rhett's men began boarding the pirate sloop, her captain, with two pistols drawn, tried to force his way below deck to ignite the gunpowder. But the rest of the pirates had seen enough bloodshed and wrestled their captain to the deck. Rhett had suffered twelve men killed and eighteen wounded. Seven pirates had been killed and five wounded, two of whom would die later of their wounds. Accepting that his crew had determined to take their chances in court rather than fight to the death, the pirates' captain turned to Rhett and surrendered his sloop *Royal James*. Submissively handing over his sword, the captain identified himself as Stede Bonnet.

Poor Stede—his fortunes had not improved since leaving Blackbeard at the *Queen Anne's Revenge*'s wreck at Topsail Inlet. Successfully obtaining his pardon and a commission to sail to St. Thomas from Governor Eden of North Carolina, Stede returned to Topsail Inlet to find that Blackbeard had double-crossed him. All of the plunder and provisions had been removed from the *Revenge* to the *Adventure*, and Blackbeard had long sailed away.

Stede Bonnet surrenders to William Rhett at the Cape Fear River in the aftermath of the Battle of the Sand Bars. *Drawing by Howard Pyle.*

Blackbeard had decided after the blockade at Charleston to break up his huge company of pirates and ships and keep the hard-earned plunder for himself and a select crew of about one hundred pirates. The grounding of the *Queen Anne's Revenge* had been intentional, and as soon as Stede had left for Bath, Blackbeard sprung the second part of his plan into action. Those loyal to Blackbeard drew their weapons on their former crewmates and stole away in the *Adventure*.

The majority of the betrayed pirates were left behind at Topsail Inlet, but twenty-five men, including Stede's friend David Herriot and his former crew of the captured *Adventure*, were marooned on a small, uninhabited spit of sand (most likely Bogues Bank, located about a mile from present-day Beaufort, North Carolina). The men were left "no doubt with a design they should perish, there being no inhabitant, or provisions to subsist withal, nor any boat or materials to build or make any kind of launch or vessel, to escape from that desolate place. They remained there two nights and one day, without subsistence, or the least prospect of any, expecting nothing else but a lingering death." Stede was tipped off by some of the pirates still lingering at Topsail Inlet of the stranded crew's location, and all were rescued.

A meeting was held on the *Revenge* to decide the crew's next course of action. Stede, with his pardon in hand, pressed his plan to sail to St. Thomas and receive a privateer commission. However, when a small boat selling apples and cider approached the *Revenge* and its captain told the former pirates that he had seen Blackbeard just two days prior at Ocracoke Inlet, the angry crew demanded vengeance. The new crew of the *Revenge* was no longer the salaried pirates with whom Stede had sailed out of Barbados over a year earlier. Decisions were now made in the traditional pirate way: through a vote. The crew overwhelmingly voted to sail north to Ocracoke. Arriving a day later, the crew did not find Blackbeard or the *Adventure* at the secluded anchorage. The *Revenge* had just missed catching Blackbeard; he had sailed across the Pamlico Sound toward Bath the day before to collect his pardon from Governor Eden.

With few provisions or goods onboard the *Revenge*, the crew had little choice but to return to piracy. Stede protested, but the crew, incited by an aggressive crew member named Robert Tucker, unanimously decided to return to their former trade. Tucker had joined the crew of the *Queen Anne's Revenge* when Blackbeard captured the sloop from Bermuda on which he served. Faced with either being set adrift or joining the pirates, Tucker had chosen the latter. But for however reluctantly Tucker may have joined the pirates' ranks, he now embraced the lifestyle and was voted quartermaster

of the *Revenge*. Tucker would become captain of the *Revenge* in everything but name, and such was the crew's affection for him that they referred to Tucker as "Father." In an effort not to invalidate his pardon, Stede told the crew to refer to him as "Captain Thomas," and he changed the name of the *Revenge* to the *Royal James*—in homage to his own Jacobite sentiments.

During the pirates' first couple attacks, Stede, desperately trying not to cross the line back into piracy, took the unprecedented step of giving compensation to seized prizes. A ship captured just outside Ocracoke was given a small amount of molasses and rice in exchange for provisions that were forcibly taken out of her hold. Another prize from Glasgow also received molasses and rice for a stolen cargo of tobacco. However, by the time the pirates reached the busy shipping lanes off Virginia, Stede's policy of forced bartering had been abandoned, and Robert Tucker was growing increasingly hostile and frenzied in his attacks. No fewer than thirteen merchant ships were taken between Virginia and New Jersey. On July 29, the fifty-ton sloop *Fortune*, commanded by Thomas Read, bound from Philadelphia to Barbados, was captured off Cape Henlopen. Storming onboard the *Fortune* with several other pirates, Tucker "fell to beating and cutting the people with his cutlass, and cut one man's arm."

Two days later, with the *Fortune* detained alongside, the pirates spotted a sixty-ton sloop named the *Francis* anchored nearby. Tucker and several other pirates approached the *Francis* in their longboat. When the crew of the *Francis* called for the approaching strangers to identify themselves, Tucker feigned to be the *Fortune*'s captain, Thomas Read. The *Francis*'s crew welcomed the visitors to come aboard, but as James Killing, first mate of the *Francis*, would later testify, "So soon as they came on board, they clapped their hands to their cutlasses, and I said we are taken." Storming into the cabin of the *Francis*'s captain, Peter Manwareing, the pirates held an impromptu celebration, toasting their allegiance to the Jacobite cause. Killing describes the scene:

> So when they came into the cabin, the first thing they began with was the pineapples, which they cut down with their cutlasses. They asked me if I would not come and eat along with them. I told them I had but little stomach to eat. They asked me why I looked so melancholy. I told them I looked as well as I could. They asked me what liquor I had on board. I told them some rum and sugar. So they made bowls of punch and went to drinking of the Pretender's health and hoped to see him King of the English nation. Then sang a song or two.

With the height of hurricane season approaching, the pirates forced the captured *Fortune* and *Francis* to sail in consort with the *Royal James* to North Carolina to seek the shelter of an inlet and perform careening operations. At one point during their southbound voyage, Stede noticed that the *Francis* was slipping away from the *Royal James*'s starboard quarter. He barked through the speaking trumpet that if the crew of the *Francis* "did not keep closer, he would fire in upon them and sink them." The *Royal James* and her two prizes would arrive at the Cape Fear River in mid-August.

It was the masts of the *Fortune* and *Francis* that Rhett had seen hovering above the tree line alongside that of the pirate sloop when he arrived at the Cape Fear River. With Stede and the other surviving thirty-seven pirates detained (two would die that day of their wounds), Rhett took inventory of the pirates' plunder. Admiralty records list the cargo found in the *Royal James*'s hold, which included ten slaves named Prince, Francois, Sampson, Yellowbelly, Mingo, Toby, Peter, Ned, Little Mingo and Ruby, as well as twenty barrels of pork, two barrels of flour and some bread. It was a piddling and unremarkable sum of merchandise considering Stede had been a pirate for more than a year. Even more confounding was the fact that the small amount of plunder that was found on Stede's sloop were all items readily available on his sugarcane plantation back in Barbados.

Rhett's men proceeded upriver to secure the prizes *Fortune* and *Francis*. Onboard, they found both Captain Read and Captain Manwareing, who had by this time been prisoners of the pirates for nearly two months. Remaining in the Cape Fear River for three more days to tend to the wounded and make repairs to damaged ships, the *Henry*, *Sea Nymph* and *Royal James*, as well as the pirate prizes *Francis* and *Fortune*, set sail together southbound on September 30, arriving in Charleston on October 3 "to the great joy of the whole province."

With no formal jail in Charleston, all of the pirates, except for Stede, were held in the Court of Guard building—a small, wooden, two-story structure on the Half Moon Battery. Stede was held separately in the home of Charleston's provost marshal, Nathaniel Partridge. Proprietary records put the location of Partridge's home at the southeast corners of modern-day Tradd and Church Streets. Historians have long recorded that Stede's upgrade in lodgings was due to his status as a "gentleman," but it is more likely that Stede was separated from his crew to prevent him from conspiring and inciting his former shipmates to attempt escape. The Court of Guard was not designed for detaining prisoners, and although pirates had brought the city terror and insult, there were still many in Charleston who supported

the newly arrived crew of the *Royal James*. A false notion spread, particularly among the under class of the city, that the imprisoned men were not pirates but "adventurers" and that the wealthy Stede had chosen to leave his life of privilege to become a Robin Hood–like figure, robbing from only the wealthy and elitist.

Crowds of pirate supporters began to loiter around the Court of Guard and outside the Partridge home. Nervous soldiers shouldered muskets as the raucous, growing mob hurled insults and threats. Stede became somewhat of a celebrity, especially among the ladies of Charleston. Attorney General Robert Allein reported, "I am sorry to hear some expressions drop from private persons in favour of the pirates, and particularly Bonnet; that he is a Gentleman, a Man of Honor, a Man of Fortune, and one that has had a liberal education." Charleston was falling into a "state of chaos," and the authorities were anxious to start the pirates' trials. On October 17, an emergency assembly meeting was held at St. Philip's Church to pass a measure called "An Act for the More Speedy and Regular Trial of Pirates." The act streamlined the jury selection process, as well as defining the court's jurisdiction, which was conveniently worded to include Stede and his crew's

An artist's rendering of the Court of Guard building that stood at the Half Moon Battery. It was here that pirates were held while awaiting trial and execution in Charleston. *Photo courtesy of the Old Exchange and Provost Dungeon, 122 East Bay Street, Charleston.*

transgressions. The act even denied the captive pirates the comfort of a priest, stating, "The offender or offenders shall not be admitted to have the benefit of his or their clergy, but be utterly excluded from the same."

Stede was soon joined in Partridge's home by his friend David Herriot and the *Royal James*'s boatswain, Ignatius Pell. Both men had agreed to testify against their former crew in return for immunity. For their own safety, they were removed from the Court of Guard. Herriot and Pell gave Attorney General Richard Allein and Assistant Attorney General Thomas Hepworth a lengthy deposition detailing the piratical activities of the imprisoned pirates starting from the time of the *Adventure*'s capture by Blackbeard at Turneffe the previous April. Most damning for Stede and the other pirates were Herriot's and Pell's statements regarding the seizure of the *Francis* and *Fortune*. The prosecution, with both Captain Read and Captain Manwareing in Charleston and available to testify, would focus on two indictments against the pirates—one for the seizure of the *Francis* and the other for the *Fortune*. In his deposition, Herriot would state clearly "that all the said Crew bore Arms freely and voluntarily, and were all consenting and assisting in taking the said two Sloops belonging to the said Read and Manwareing."

While the prosecution was preparing its case against the pirates who were driving Charleston to near bedlam, a newly arrived ship brought news that sent the city into sheer panic. The captain of the merchantman from Boston reported that his ship had just been seized off the Charleston bar by the pirate Christopher Moody in a brigantine of fifty guns and more than two hundred men. Wild rumors spread through Charleston that Moody intended to enter the harbor and lay siege to the city to secure the freedom of his imprisoned brethren. The rumors reached Stede locked in Partridge's home, and he knew that Moody could be his one opportunity for escape. On the night of October 25, disguised as a woman in one of Mrs. Partridge's shawls, Stede slipped out of the Partridge house and into the dark streets of Charleston. Strangely, David Herriot joined Stede in his escape. One can only speculate why Herriot, who had turned state's evidence just the day before, would choose to compromise his immunity from prosecution and flee with Stede—perhaps it was due to Herriot's sense of guilt for his betrayal of his friend. The two men made their way under the southern wall's palisades along Vanderhorst Creek, where a canoe was waiting. The canoe had been supplied by one of the many pirate supporters in the city. Admiralty records lend themselves to fingering a local merchant named Richard Tookerman as the man who supplied the canoe. While the city slept, several slaves, also provided by Tookerman, silently paddled Stede and Herriot across the harbor.

Christopher Moody's flag.

The following morning, when Stede's escape was discovered, a general alarm was raised in the city with "hue and cries and expresses by land and by water, throughout the whole province; so that it is hoped he will be retaken." Governor Johnson offered a reward of £700 sterling for Stede's capture. Although no official charges were filed, it was clear that Nathaniel Partridge had been complicit in the escape. Like Stede, Partridge was also from the parish of Christ Church in Barbados. It is even possible, if not probable, that Partridge knew Stede's father and uncle. In a will that Partridge prepared in November 1689 before leaving Barbados, he describes his future plans as "bound on a voyage beyond the seas." Like for many Barbadians, this "voyage" would lead Partridge to Charleston to join the growing mass of immigrants from the sugar island. Seven of the province's earliest governors had come from Barbados. The general sentiment in the city was that Stede had played on the sympathies of his fellow Barbadian and bribed Partridge to facilitate his escape. The authorities' belief that Partridge played a role in the escape is evidenced by the fact that he was fired from his position as provost marshal several days later and replaced by Thomas Conyers.

Determined to proceed with trial, even without the absent Stede, a vice-admiralty court was convened on October 28. Lacking a formal courtroom in the city, the trial was held in the home of shoemaker Garrett Vanvelsin. The home of the humble cobbler was most likely chosen for two reasons. First, records show that Vanvelsin lived adjacent to Nathaniel Partridge's

house within the confines of city lot seventy-three. Prior to Stede's escape with the obvious assistance of the since-dismissed Partridge, authorities probably wanted to choose a location for trial near the provost marshal's house to shorten Stede's transfer distance and subsequently limit access to the mob lingering outside Partridge's house. Secondly, Vanvelsin's house was probably divided into two parts, with lodgings on the second floor and a wide, open workshop on the first floor. Plenty of space would be needed for the trial. Besides the pirate defendants, the courtroom would include Judge Nicholas Trott, ten assistant judges, Attorney General Richard Allein and Assistant Attorney General Thomas Hepworth, as well as twenty-three jury members.

Unlike the theoretically unbiased and unprejudiced jury selection process of the modern day, the twenty-three jury members who would determine the pirates' fate certainly had prior knowledge of the defendants' crimes, and many had probably been personally affected by the crime of piracy. Many of the jurors, like foreman Michael Brewton, were wealthy plantation owners whose burgeoning wealth through the cash crop of rice had drawn many of the pirates to hunt the waters of Charleston. Several of the jurors, like Peter Manigault, were Huguenots, who, as discussed in an earlier chapter, brought to the province a strong sense of piety and the discouragement of cooperation and toleration of pirates. Further stacking the odds against the pirates was the fact that they were not allowed the benefit of a defense counsel. Vice-admiralty courts were grounded in the 1696 Navigation Acts whose edicts greatly limited the rights of those charged with piracy.

Though spacious, Vanvelsin's workshop still was not large enough to fit all of the judges, prosecutors and jurors, as well as all thirty-three pirates. Subsequently, the pirates were tried in groups ranging from five to eight at a time. All were arraigned on two indictments, the first for the seizure and plunder of Captain Manwareing's *Francis* and the second for Captain Read's *Fortune*. In the prosecution's overwhelming case against the pirates were five eyewitnesses, including the absent David Herriot, whose testimony had already been recorded; Ignatius Pell; Captain Peter Manwareing; James Killing, Manwareing's first mate; and Captain Thomas Read. Judge Nicholas Trott opened the proceedings with his charge to the assembled jury in which he detailed the meaning and nature of the crime of piracy and the need for and jurisdiction of a vice-admiralty court to "punish the heinousness and wickedness of the offense of piracy." Trott made his bias of the pirates' guilt evident in his opening statement, which reminded the jury of Charleston's recent difficult history with pirates and the defendants' connection to Blackbeard's blockade:

And indeed, the Inhabitants of this Province have of late, to their great Cost and Damages, felt the Evil of Piracy, and the Mischiefs and Insults done by Pirates; when lately an infamous Pirate had so much Assurance as to lie at our Bar, in sight of our Town, and to seize and rifle several of our Ships bound inward and outward. And the Success he had in going off from our Coast with Impunity, encourag'd another [Vane] of those Beasts of Prey to come upon our Coast, and take our Vessels. And this very Company, which will now be charged before you with the Crime of Piracy, their Ringleader, with many, if not all of the Company, were belonging to that Crew, which first insulted us. And presuming upon their form Success and Impunity, had the Confidence to lie upon our Coast to fit their Vessel, and to go on Shore at their Will and Pleasure: designing, as we had just reason to suppose, that when all things were fitted for their mischievous Designs, to come again to cruize [sic] before our Bar, and take our Vessels.

Despite a prejudiced judge and jury and the prosecution's insurmountable evidence and eyewitnesses, all thirty-three pirates pleaded not guilty. During the trial, which would last for eight days, the convicted pirates were able to offer very little in the way of defense. Most repeated the explanation provided by their former quartermaster and the man they had once referred to as Father, Robert Tucker. Tucker told the court, "After Captain Thatch [Blackbeard] had taken what we had and left us, Major Bonnet came and told us that he was going to St. Thomas for the Emperor's commission, if there was any to be had. We had but little provisions on board and were forced to do what we have done." But Nicholas Trott was quick to rebuke any claims of the acts of piracy being committed for purposes of survival. Trott countered, "But pray, what did you with so much molasses, which was neither fit to eat or drink?" Several pirates confessed to having been with Blackbeard during the blockade but declared themselves unwilling participants. When Trott asked why the men had not come ashore in Charleston and left their "wicked life" behind, most responded in a similar fashion to Edward Robinson, who stated, "I would have come on shore, but Capt. Thatch [Blackbeard] would not give me leave. I was with Mr. Wragg, and told him I would go on shore if I had liberty."

Thomas Carman testified that he was forced into piracy by Blackbeard and had only stayed on with the pirates for the food provided on board and he was merely waiting for the right moment to escape. Carman explains:

As for what I did on board Capt. Thatch, I was forced, but when I came to North Carolina, I would not have went on board, but Major Bonnet

showed me the Act of Grace and when I enter'd myself on board, it was to get my Bread, in hopes to have went where I might have had Business, for when we left Topsail-Inlet, I had not signed the Articles. When I was left in the Sloop, I endeavored to make my escape with the Sloop.

When accusations of murder were lodged against the pirates for their actions in the engagement with Rhett and his men at the Cape Fear River, several pirates, like Job Bayly, stated, "We thought it had been pirates." In an effort to inspire the crew on the morning of their battle with Rhett's men, Stede had apparently told at least some of the crew that it was Blackbeard waiting for them at the mouth of the Cape Fear River. Trott responded to Bayly's claim, "But how could you think it was a pirate, when he had King George's colours?" Read, Manwareing, Killing and Pell were all called to the stand, and it was their eyewitness testimony that sealed the pirates' fate.

On Tuesday, November 4, the jury returned from its deliberations with a verdict. Twenty-nine of the thirty-three pirates were found guilty. Among the four men spared were Thomas Nichols, who had convincingly testified that he was forced unwillingly to serve on the *Royal James*. Pell, Manwareing and Killing corroborated Nichols's story. Killing testified:

When he came on board, he told me, he would give the whole world if he had it, to be free from them; and when he was on board, and Major Bonnet sent for him; he refused to go on board the Revenge, *till he sent to fetch him by force, and then he told me he would not fight if he did lose his life for it; and he was not with them when they shared; and he told them he hoped he should not be long with them.*

Testimony revealed that Stede had threatened to shoot Nichols during the battle at the Cape Fear River for his refusal to fight. Thomas Gerard, who was a mulatto, was found not guilty when he presented evidence that he had been threatened by Stede to be sold into slavery if he did not sign the articles. He further recounted that he did not take any shares of the plunder from the *Francis* or *Fortune*, a claim that was supported by Captain Manewareing. Rowland Sharp and Jonathan Clarke were both able to prove that they were forced men. Clarke had blundered into the company of the pirates in the Cape Fear River and was taken aboard the *Royal James*. When he refused to sign the articles, Clarke testified, "He [Stede] said he would make me Governor of the first island he came to; for he would put me ashore, and leave me there." Rowland Sharp related the following harrowing tale:

After I was taken, I went on shore, and traveled four days in the woods without eating or drinking, and could find the way to no plantation, and so was forced to return again, and I refused to sign the Articles; and one of the men came and told me I was to be shot, and I had the liberty to choose the four men that should do it, and the boatswain went about to get hands to beg me off; but I was resolved to make my escape the first opportunity.

At sentencing the following day, Trott delivered a long, Bible verse–laced speech condemning the pirates as failures and traitors to mankind. Trott described, "And indeed, most sad and deplorable is the condition you have brought your selves to. To be ajudg'd by the laws of your country unworthy any longer to live, and to tread the earth, or breathe this air; and that no further good or benefit can be expected from you but by the example of your deaths; and to stand like marks or fatal rocks and sands, to warn others from the same shipwreck and ruin for the future." Trott offered the pirates little in the way of comfort for their immortal souls, stating, "I suppose you all know that you must appear before the Tribunal of Christ; from whose infinite knowledge none of your actions can be hid, and from whole infinite power no one can rescue you, or protect you; and from whom, without a true and unfeigned repentance for all your sins past, you can expect no other than that dreadful sentence of condemnation." Trott then quotes Matthew 25, verse 41: "Depart from me, ye cursed, into everlasting fire, prepared for the Devil and his angels."

The court was adjourned upon Trott's announcement of sentencing of the twenty-nine condemned men: "You shall go from hence to the place from whence you came, and from thence the place of execution, where you shall be severally hanged by the neck, till you are severally dead."

CHAPTER 6

Extermination

David Herriot awkwardly shuffled his feet in the loose sand, thrusting a hand forward to find his balance as he climbed to the top of the sand dune. On the beach below, Stede braced himself against the blustering wind as his coat flapped wildly. Stede shaded his eyes as he stared into the blank horizon. Herriot, shaking his head, sighed with disappointment and dismay and trudged back to the camp that he had shared with Stede and Tookerman's slaves for the last twelve days. A strong northeasterly wind had blown since the group set off from Vanderhorst Creek on the night of their escape. Unable to paddle their canoe against the contrary wind, the refugees had only managed to make it across the harbor to the western end of Sullivan's Island. A small camp sat concealed between dunes in the ant-filled brush. The obstinate Stede had begun a vigil, watching and waiting for Christopher Moody to appear and provide rescue.

Stede passed through the narrow gap in the dunes and returned to the camp to briefly warm himself by the fire. Joining Herriot on the gnarled oak log that served as a fireside bench, Stede listened to Herriot chastise him for his devotion to his fruitless watch. As Herriot had done for the last twelve days, he again encouraged Stede to lead the group on an overland journey north to put some distance between themselves and the authorities in Charleston. But the stubborn Stede refused, assuring Herriot that Moody would be their salvation. Herriot angrily drove the stick, with which he had been stoking the fire, deep into an ashen, smoldering log. Rising to his feet, he nervously craned his neck as movement was heard coming from dunes

behind the camp. A voice called out, "Surrender yourselves!" and Stede instinctively reached for the pistol stuffed in his belt. Musket shots rang out, and two of the slaves screamed in agony as shot tore through their bodies. Herriot, with his back turned to Stede, took one step backward before collapsing into Stede's arms. Unable to support Herriot's weight, Stede eased his friend to the ground, where he saw the bloody hole in Herriot's head. Emerging from the gun smoke that had settled between the dunes, Stede saw the familiar face of William Rhett.

As Rhett's prisoner once again, Stede was ferried back across the harbor in a small boat. The harbor and its wharves were still full of the same ships that had been present when Stede had slipped out of Partridge's house nearly two weeks earlier. No ship dared sail out of the harbor with Christopher Moody still assumed to be lurking offshore. Rhett told Stede of his former crew's trial and sentence to hang, which had been announced the previous day. Back in the city, Stede was briefly reunited with his doomed crew at the Court of Guard. However, two days later, on November 8, Stede watched horrified as the twenty-nine condemned men were forcibly loaded into carts and paraded down Broad Street toward the city's western gate. Turning left along the outside of the city's wall and passing out of Stede's sight, the men were hauled to White Point (today known as the Battery) and hanged. The vice-admiralty court's jurisdiction reached as far as the mark of high tide, so the hangings would have coincided with the low tide. As each hanged pirate stopped writhing and twisting, or doing what came to be called the "hangman's jig," he would be cut down and his lifeless body thrown in a shallow grave in the mud just beyond the low tide. The denial of a proper Christian burial was the final insult to a pirate; he would never find rest as his remains shifted in the ever-turning tides.

With the hangings completed, the authorities in Charleston turned their attention to Christopher Moody's threat off the Charleston bar. Governor Johnson convened his council and proposed a plan to station militia on Morris and Sullivan's Islands and to impress some of the merchant vessels bottled up in the harbor, outfitting them for an expedition against Moody. The *Mediterranean*, commanded by Arthur Loan, and the *King William*, commanded by John Watkinson, were chosen. The *Sea Nymph*, which had served in the Battle of the Sand Bars, again commanded by Fayrer Hall, and Stede's *Royal James*, placed under the command of John Masters, were also pressed into service. The four vessels were mounted with a total of sixty-eight cannons. The owners of the *Mediterranean* and *King William* filed formal protests with Governor Johnson demanding that some security should be

The beautiful and popular Battery at the tip of the Charleston peninsula was, in the early eighteenth century, a swampy area called White Point. Located outside the city walls, White Point was where condemned pirates were hanged and buried.

given by the government to indemnify them for the possible injury or capture of their vessels by the pirates. An emergency meeting of the assembly was held and a bill guaranteeing the shipowners against any losses and expenses was passed.

Only a few days after the hanging of Stede's crew, a ship and a smaller sloop crossed the bar and anchored just off Sullivan's Island. A landing party in several longboats set off for the beach but quickly returned to their ship when the force of militia emerged from the dunes. Both of the strange vessels then weighed anchor and moved to the mouth of the harbor. Convinced that it was Moody, Governor Johnson asked William Rhett to lead the attack the following morning. However, the temperamental Rhett refused. History does not record the cause of their differences, but there was apparently a quarrel between Rhett and Johnson soon after Stede's capture at Sullivan's Island, and unwilling to lay aside his personal issues with Johnson, Rhett declined the command. Governor Johnson, realizing that the window for action was small, determined to lead the expedition

himself. Word that the governor was personally leading the attack from the deck of the *Mediterranean* roused the spirits of Charleston's citizens, and three hundred men volunteered to serve.

Under strict orders to cover their cannons and to keep their large crews concealed below decks, the four vessels appeared to be simple merchantmen as they sailed across the harbor toward the two suspicious ships. The pirates fell for the ruse and quickly weighed anchor and hoisted their black flag to their mast tops. The pirates maneuvered so close that they were able to call out for the *King William* to surrender. At this very moment, Johnson ordered the gun ports of the *Mediterranean* opened and a broadside fired. The cannon fire razed the pirates on the deck of the smaller sloop. The shocked pirates frantically tried to flee, but the *Mediterranean*'s broadside signaled all of the governor's three hundred men to pour onto the decks of all four ships, and the fleet's combined sixty-eight guns erupted. The smaller sloop was hemmed against the beach and taking deadly fire, but the larger pirate ship was able to make its escape and stood for the open sea.

Johnson signaled for the *King William* to follow the *Mediterranean* in pursuit while the *Sea Nymph* and *Royal James* continued their fight with the smaller pirate sloop. Standing on the ramparts of the city walls, the people of Charleston watched the *Sea Nymph* and *Royal James* duel with the pirate sloop for nearly four hours. The fighting was at such close quarters that at times the pirate sloop rubbed yardarms with those of the *Sea Nymph* and *Royal James*. The pirates fought viciously, but eventually most were unable to withstand the fire that swept their sloop from stem to stern, and they retreated below deck. The Charlestonians boarded the sloop, and the few men left on deck, including the pirates' captain, fought until they fell from musket shot and cold steel. The bloody and injured pirates sheltered below deck surrendered. The battered sloop was towed back to the city wharves with the pirates in irons, creating "the most tremendous excitement among the inhabitants."

The *Mediterranean* and *King William* faced a long, hard chase of the escaped pirate ship. During the pursuit, the pirates abandoned any plans for defense and jettisoned their cannons in an effort to lighten their ship and gain speed. However, Johnson's ships still proved faster, and when within range, Johnson signaled the *King William* to fire a broadside. Sail and rigging crashed to the deck, and two pirates fell dead. Striking their colors, the pirates hove to and surrendered. Onboard the pirate ship, Johnson and his men were shocked when the hold of the ship was found to be crowded with 106 convicts and "covenant servants," 36 of whom were women. The ship, which the pirates had renamed the *New York Revenge's Revenge*, was previously the merchant ship

Governor Robert Johnson would serve as the last proprietary governor. South Carolina would stage a bloodless revolution overthrowing the Lord Proprietors. As a royal colony, the popular Robert Johnson would return to serve as governor again in 1729.

Eagle. When captured in late October near Cape Henry by the smaller pirate sloop now detained in the harbor, the *Eagle* had been bound from London to Virginia and Maryland with its cargo of convict labor and indentured servants, including the 36 women who were planned to be taken as wives in the colonies. Even more surprising than the *Eagle*'s strange cargo was the report of the *Eagle*'s chief mate, Edmond Robinson, that the pirates who seized his ship were not under the command of Christopher Moody but rather the infamous Richard Worley.

Little is known about Worley prior to his arrival in Charleston. He had been a pirate for only six weeks, and although short, his pirate career had been remarkable. Setting out from New York in the latter part of September in an open boat with only eight crewmembers, Worley's first act of piracy was the plundering of a small vessel at Delaware Bay. When his ship was released, the captain promptly reported the seizure of his vessel to authorities in Philadelphia, prompting the governor of Pennsylvania to order the royal warship *Phoenix*, anchored at Sandy Hook, to begin a search for Worley. The *Phoenix* scoured the coast, but Worley wisely stood out to sea until the threat

had passed. Returning to his hunt, Worley captured a sloop, on which he mounted six guns and then named the *New York's Revenge*. Sailing south, the *Eagle* was seized off the coast of Virginia and, quite unoriginally, renamed the *New York Revenge's Revenge*. Edmond Robinson described the capture of his ship by Worley during later trial testimony:

> On the 24th Day of October last being in about the Latitude of Thirty Seven Degrees North, and Thirty Five Leagues distant from Cape Henry, met with a certain Pyrate Sloop, named the New York's Revenge, Commanded by one Richard Worley, a Pyrate since Dec'd who Chased the said Ship Eagle Galley all that Day, and fired a volley of small arms at them, and kept them Company all that night, and the next Day being the Twenty fifth of the said October, the said Pyrates hoisted a black Flagg with a humane Skelleton on it which so much terrified the Said Ship Eagle's Company, that the men not only refused to fight, but also hindered the Officers themselves in their Duty of Defending the said Ship Eagle Galley, and many of them ran into the hold whereupon the Said Pyrate Crew came up along side the Said Eagle Galley, and swore that if the Eagle's company would not strike their pennant, they would kill every soul of them, which was done...That the said Pyrates having as aforesaid gotten possession of the Said Ship Eagle Galley barbourisly beated the Said Staples and Severall of his men for being so bold as to fire at them, and then forced the Said Staples and all the others into the Said Pyrate Sloop...And the Said Pyrate afterwards called the Said Ship Eagle Galley by the name of the New York Revenge's Revenge, and put on James Cole, a Pyrate, to Command her as Captain thereof, together with other Pyrates. That the Said Pyrates having New named the said Ship Eagle Galley, and named her as aforesaid, came and lay off the Barr of Charlestown.

Shackled in the Court of Guard, Stede had heard the battle between the *Royal James*, *Sea Nymph* and *New York's Revenge* roaring across the harbor. With the cessation of cannon fire and cheers of the crowd, Stede knew that his hopes for rescue by his pirate brethren had dissolved. Worley had been killed during the engagement with the *Royal James* and *Sea Nymph*, but the few members of his crew who did manage to survive the ferocious battle were detained with Stede in the Court of Guard. Bloodied and mangled, several succumbed to their wounds before even reaching the Half Moon Battery. The *Mediterranean* and *King William* triumphantly returned to Charleston

Richard Worley's flag.

with the *Eagle* late in the evening and released their prisoners to Provost Marshal Thomas Conyers. Stede would eventually share his uncomfortable quarters with more than twenty surviving members of Worley's crew.

Governor Johnson assumed that Christopher Moody was still lurking offshore, and he kept the city on alert. However, anxieties were relieved when Captain Smyter of the newly arrived *Minerva* from the Madeira Islands reported that he had been seized by Christopher Moody off the Charleston bar several days earlier. Moody had been warned of the force in Charleston that was being prepared to subdue him, so he took the *Minerva* several hundred miles offshore and plundered her before heading south to Nassau to obtain the king's pardon from Woodes Rogers.

With Charleston's immediate threat from pirates removed, attention returned to the courts. A vice-admiralty court was convened again at Garret Vanvelsin's house on Monday, November 10, Judge Nicholas Trott presiding, wherein "the court proceeded to arraign Stede Bonnet, alias Edwards, alias Thomas, for feloniously and piratically taking the sloop *Francis*, with her goods, Captain Peter Manwareing commander; and the sloop *Fortune*, with her goods, Captain Thomas Read, commander." Stede pleaded not guilty to

both charges, to which Trott responded, "You are to come upon your trial this day, upon the first indictment, and you have pleaded not guilty; so that what evidence you have must be ready."

Stede coolly replied, "My pleading not guilty is because I may have something to offer in my defense; and therefore I hope none of the bench will take it amiss."

Assistant Attorney General Thomas Hepworth then addressed the jury, pointing to Stede's escape as a veritable admission of guilt and pinning on Stede the death of the prosecution's witness, David Herriot:

> *You know (all of ye) I believe, after what manner he lately fled from justice. Nay, not being satisfied with his own escape, but he must tamper with the King's evidence, to avoid others being prosecuted; and prevailed with the Master Herriot to run away with him, who has since been killed. And I believe the prisoner at the Bar cannot by reflecting but think himself answerable for that man's death.*

Stede was first tried for the indictment of the capture of Manwareing's *Francis*. Ignatius Pell was again called to the stand to recount the pirates' activities since he joined ranks at the Bay of Honduras. Pell, though a witness for the prosecution, seemed to still harbor some affection for his former captain. Following the defense model of his late crew, Stede claimed that his intentions at Topsail were to sail to St. Thomas and seek a privateering commission. When Stede asked Pell, "Don't you believe in your conscience, that when we left Topsail Inlet, it was to go to St. Thomas?", Pell agreed. Judge Trott countered that Stede's former crew had testified "that you [Stede] deceived them; under the pretence of going to St. Thomas."

Stede calmly responded, "I am sorry that they should take the opportunity of my absence to accuse me of that that I was free from." Stede also attempted to downplay his role as leader of the pirates, pointing to the deceased Robert Tucker as the antagonist who had pushed the *Royal James*'s crew to piracy. Trott asked Pell if Stede was the "Commander and Chief among them," to which Pell replied, "He went by that name, but the Quarter-Master had more power than he." However, when Manwareing was called to the stand, his testimony would paint Stede as a willing participant, and even ringleader, in the *Royal James*'s acts of piracy. Manwareing's testimony seems to show that, like Pell, he still shared a fondness for his former captor, but when Stede directly asked Manwareing, "Did you ever hear me order anything out of the sloop?" an emotional Captain Manwareing replied, "Major Bonnet,

I am sorry you should ask me the question; for you know you did which was my all, that I had in the world. So that I do not know but my wife and children are now perishing for want of bread in New England. Had it been only myself, I had not mattered it so much; but my poor family grieves me."

Manwareing would also testify that on the night before the battle in the Cape Fear River, Stede had called him into his cabin. Stede had correctly guessed that the force waiting for him at the river's entrance had been sent from Charleston, and he showed Manwareing a letter that he intended to send if he were to escape. Manwareing testified that the contents of the Stede's letter threatened "that in case the vessels which then appeared were sent from South Carolina to fight or attack them, and he got clear off...he would burn and destroy all vessels going in or coming out of South Carolina."

Stede did call one witness for his defense: a young man from North Carolina named James King. King testified that he had been told by a Colonel Brice, who apparently shared a close relationship with North Carolina governor Charles Eden, that Stede had received a commission from Eden to sail to St. Thomas to receive a privateering license against Spain. Unimpressed with King's second-hand account, Trott said to Stede, "If this be all the evidence you have, I do not see this will be of much use to you."

When Trott directly lodged the question, "Did you not take Captain Manwareing's sloop?" Stede weakly and pathetically responded, "It was contrary to my inclinations...and when Captain Manwareing was taken, I was asleep." Growing increasingly desperate, Stede summarized his defense to the jury:

> *May it please your honours, and the rest of the gentlemen, though I must confess myself a sinner, and the greatest of sinners, yet I am not guilty of what I am charged with. As for what the boatswain says, relating to several vessels, I am altogether free; for I never gave my consent to any such actions for I often told them, if they did not leave off committing such robberies, I would leave the sloop; and desired them to put me on shore. And as for Capt. Manwareing, I assure your honours it was contrary to my inclination. And when I cleared my vessel at North Carolina, it was for St. Thomas and I had no other end or design in view but to go there for a commission. But when we came to sea, and saw a vessel, the quartermaster, and some of the rest, held a consultation to take it but I opposed it, and told them again I would leave the sloop, and let them go where they pleased. For as the young man said...that I had my clearance for St. Thomas.*

The jury deliberated for only a short time before jury foreman, Timothy Bellamy, announced its verdict: guilty. When the court was reconvened the following day to begin proceedings for the second indictment for the capture of Captain Read's *Fortune*, the court was quickly adjourned when the despondent Stede withdrew his previous plea of not guilty and reentered a plea of guilty. The following day, November 12, the pious Nicholas Trott addressed Stede, shaming the "gentleman" for his corruption and reminding Stede of his need for repentance:

> *You being a gentleman that have had the advantage of a liberal education, and being generally esteemed a man of letters, I believe it will be needless for me to explain to you the nature of repentance and faith in Christ, they being so fully and so often mentioned in the scriptures, that you cannot but know them…but that considering the course of your life and actions, I have just reason to fear that the principles of religion that had been instilled into you by your education, have been at least corrupted, if not entirely defaced, by the skepticism and infidelity of this wicked age; and that what time you allowed for study was rather applied to the polite literature, and the vain philosophy of the times, than a serious search after the law and will of God, as revealed to us in the Holy scripture.*

Trott announced his sentencing, declaring, "That you, the said Stede Bonnet, shall go from hence to the place from whence you came, and from thence to the place of execution, where you shall be hanged by the neck till you are dead. And the God of infinite mercy be merciful to your soul."

There would be only a brief respite for Trott and the vice-admiralty court. Worley's crewmen sharing the dingy, cramped space of the Court of Guard building with Stede were growing increasingly weak and sick as their wounds became infected. Several had died of their wounds since arriving at the Court of Guard. Anxious to try the nineteen surviving pirates before anymore could die, a vice-admiralty court was convened on November 19. With the courtroom filled with bandaged pirates, some only semiconscious, Trott quickly moved through the proceedings, adjourning the court on November 24 with all nineteen men found guilty and sentenced to death. Two days later, Worley's former crew was taken to White Point and hanged.

Stede, who had now seen no fewer than forty-eight men removed from the Court of Guard to be hanged, began a letter-writing campaign seeking support for his sentence of death to be overturned. One of these remarkable letters, written to Governor Johnson, still exists. The reader can gauge the

sense of real desperation with which Stede was afflicted. The letter refers to "three Christian men" whom Stede offers as character witnesses, but these men's identities have been lost to history:

Honoured Sir;

I Have presumed on the Confidence of your eminent Goodness to throw myself, after this manner at your Feet, to implore you'll be graciously pleased to look upon me with tender Bowels of Pity and Compassion; and believe me to be the most miserable Man this Day breathing; That the Tears proceeding from my most sorrowful Soul may soften your Heart, and incline you to consider my Dismal State, wholly, I must confess, unprepared to receive so soon the dreadful Execution you have been pleased to appoint me; and therefore beseech you to think me an Object of your Mercy.

For God's Sake, good Sir, let the Oaths of three Christian Men weigh something with you, who are ready to depose, when you please to allow them the Liberty, the Compulsion I lay under in committing those Acts for which I am doom'd to die.

I entreat you not to let me fall a Sacrifice to the Envy and ungodly Rage of some few Men, who, not being yet satisfied with Blood, feign to believe, that I had the Happiness of a longer Life in this World, I should still employ it in a wicked Manner, which to remove that, and all other Doubts with your Honour, I heartily beseech you'll permit me to live, and I'll voluntarily put it ever out of my Power by separating all my Limbs from my Body, only reserving the use of my Tongue to call continually on, and pray to the Lord, my God, and mourn all my Days in Sackcloth and Ashes to work out confident Hopes of my Salvation, at that great and dreadful Day when all righteous Souls shall receive their just rewards: And to render your Honour a further Assurance of my being incapable to prejudice any of my Fellow-Christians, if I was so wickedly bent, I humbly beg you will (as a Punishment of my Sins for my poor Soul's Sake) indent me as a menial Servant to your Honour and this Government during my Life, and send me up to the farthest inland Garrison or settlement in the Country, or in any other ways you'll be pleased to dispose of me; and likewise that you'll receive the Willingness of my Friends to be bound for my good Behavior and Constant attendance to your Commands.

I once more beg for the Lord's Sake, dear Sir, that as you are a Christian, you will be as Charitable as to have Mercy and Compassion on my miserable Soul, but too newly awaked from an Habit of Sin to entertain so Confident Hopes and Assurances of its being received into the arms of Blessed Jesus,

as is necessary to reconcile me to so speedy a Death; wherefore as my Life, Blood, Reputation of my family and future happy State lies entirely at your Disposal, I implore you to consider me with a Christian and Charitable Heart, and determine mercifully of me that I may ever acknowledge and esteem you next to God, my Saviour, and oblige me ever to pray that our heavenly Father will also forgive your Trespasses.

Now the God of Peace, that brought again from the Dead our Lord Jesus, that great Shepherd of the Sheep thru' the Blood of the everlasting Covenant, make you Perfect in every good work to do his Will, working in you that which is well pleasing in his Sight thro' Jesus Christ, to whom be Glory forever and ever, is the hearty Prayer of Your Honour's Most miserable, and, Afflicted Servant,

<div align="right">

Stede Bonnet

</div>

Stede sent several letters to his former captor, William Rhett. These letters apparently had a profound effect on Rhett as he would lobby Governor Johnson to be allowed to personally escort Stede to London "so that his case might be referred to his majesty." Rhett even offered to finance the venture himself. Rumors spread throughout the city that Rhett's support of Stede was due to their shared Jacobite sentiments. Rhett had long been branded a Jacobite by his enemies. As proof, Rhett's detractors pointed to the portrait of the minister Dr. Henry Sacheverell that hung in Rhett's home on his estate at Rhettsbury. Sacheverell was a controversial high church Tory in London. His sermons questioning the edicts of the Glorious Revolution of 1688, which deposed England's Catholic monarchy, caused riots in London and landed Sacheverell in jail. Whatever the reasons for Rhett's support for Stede, his request to Johnson was refused. However, Rhett and Stede's other supporters in the city did manage to buy Stede some time.

Stede's execution was also delayed because the authorities' attentions were diverted by activity in the vice-admiralty court. Numerous individuals, including John Masters, commander of the *Henry*, and Fayrer Hall, commander of the *Sea Nymph*, were suing the courts for receipt of the goods and merchandise from the *Royal James* as payment for their participation in the action against the pirates in the Cape Fear River. Similar suits were filed by those citizens who had fought against Worley's pirates. Nicholas Trott's decision was to evenly split the pirates' plunder and the value of their ships among those who fought in the engagements. Trott also ruled that the "convicts and covenant servants," including the thirty-six women found onboard the *Eagle*, should be "publicly sold, or assigned over to such persons

as shall be minded to purchase them for the several terms" with the profits going to the owners of the *Eagle*.

On Wednesday, December 10, 1718, time ran out for Stede Bonnet. With his hands bound in front of him, Stede was loaded onto a horse-drawn cart and paraded up Broad Street past the throngs of people who had turned out to see his execution. The crowd followed Stede through the city's gate and over Vanderhorst Creek's bridge. Arriving at White Point, the cart was positioned beneath a simple square-framed gallows. Stede could see his shallow grave dug in the mud, knowing it lay next to the forty-eight unseen graves of those pirates hanged over the course of the previous few weeks. One of Stede's female supporters forced a bouquet of posies into his manacled hands. When offered the opportunity to address the crowd with his last words, the previously eloquent Stede was described as "scarce sensible" and unable to form any words. A forceful push in his back knocked Stede from the cart, and as the noose cinched around his neck, history's most unlikely pirate twitched and gasped until his body fell limp.

Foremost in the minds of many attending Stede's hanging, and perhaps even in the panicked, troubled mind of Stede himself, was that Blackbeard should be among the hanged and buried at White Point. However, unknown to Stede and the people of Charleston, Blackbeard had been dead for nearly three weeks.

Blackbeard had received his pardon from Governor Eden at Bath in North Carolina, and for a short time he had lived a quiet life in retirement. The infamous *Adventure*, which had been part of the Charleston blockade, was now used as a yacht for entertaining neighbors and amorous ladies. However, it was not long before Blackbeard grew weary of his sedentary life and returned to his old habits. In late August, he captured a French ship laden with sugar and cocoa bound for Martinique. The prize was brought back to North Carolina, and Blackbeard reported falsely to Governor Eden that he had "found the French ship at sea without a soul on board her." A vice-admiralty court convened in Bath found in favor of Blackbeard and awarded him the French ship's cargo. It was widely rumored that Blackbeard had paid off Eden and the court in exchange for the favorable ruling. Shortly afterward, Charles Vane, after having plundered ships off Charleston, found Blackbeard at Ocracoke Inlet, and a raucous pirate party was held on the beach. Vane proposed his plan to join forces with Blackbeard and sack Nassau, but Blackbeard, still ill, was not interested.

When news reached Lieutenant Governor Alexander Spotswood in Virginia of Blackbeard's return to piracy with the possible complicity of the

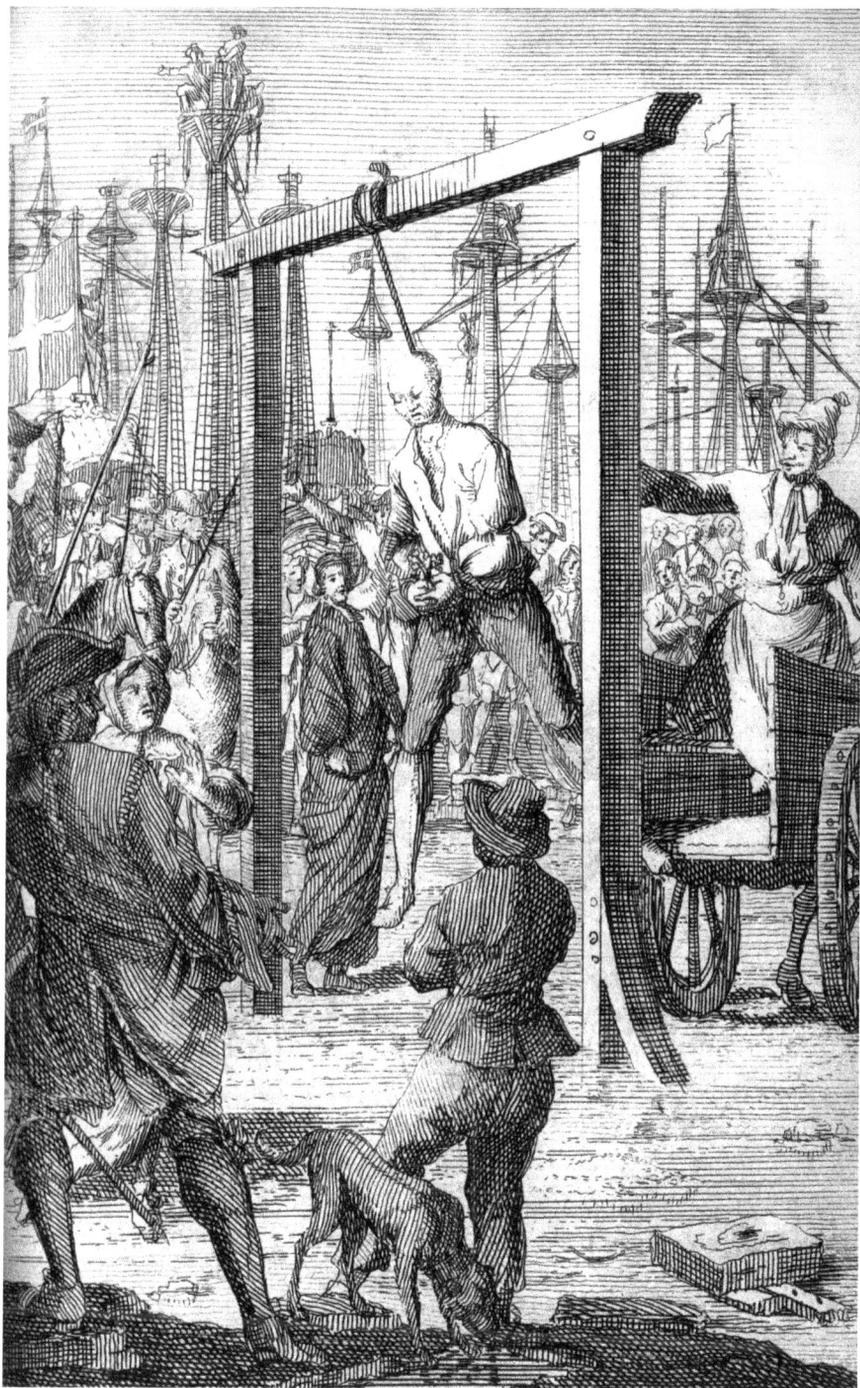

Engraving of Stede Bonnet hanged at White Point in Charleston on December 10, 1718.

Governor Eden and the stories of Blackbeard's beach party with Charles Vane, Spotswood became convinced that Blackbeard was turning Ocracoke into a base for pirate operations like Nassau. At this time, Spotswood was facing harsh criticism in Virginia. He was spending huge amounts of tax money on a home-building project in Williamsburg, which the citizens mockingly called the "Governor's Palace." Anxious to deflect attention from his "palace" and garner some good press, Spotswood met with a Captain Brand, who was stationed onboard to the HMS *Lyme* at Hampton Rhoads. Overstepping their authority, an invasion of North Carolina was planned and a force dispatched to capture or kill Blackbeard. The "Act to Encourage the Apprehending and Destroying of Pirates" was proposed by Spotswood and his council to the Virginia Assembly, which voted on and passed the measure on November 24—exactly two days after the secret force that Spotswood had sent to North Carolina had killed Blackbeard.

Two sloops, the *Ranger* and *Jane*, left the Chesapeake Bay and sailed for Ocracoke Inlet under the command of Lieutenant Robert Maynard. On November 22, the two sloops spotted the *Adventure* riding at anchor in Ocracoke. Blackbeard, on the *Adventure*, called out, "Damn you for villains, who are you? And whence you came?"

Maynard, onboard the *Jane*, answered, "You may see by our colors we are no pirates."

Raising a mug of rum, Blackbeard bellowed, "Damnation seize my soul if I give you quarter or take any from you!"

Pressing the pursuit of the *Adventure*, both the *Ranger* and *Jane* ran aground. Blackbeard fired a devastating broadside into both vessels. Utilizing one of the oldest and most deceptive of naval tricks, Maynard ordered the surviving crew to retreat below deck into the hold of the *Jane*. When the smoke cleared, Blackbeard saw the deck of the *Jane* nearly empty except for the dead and wounded. Grappling hooks were thrown from the *Adventure*, and Blackbeard ordered his pirates to storm onboard the *Jane* and kill any survivors. As the pirates rushed the *Jane*'s deck, Maynard sprung his trap and signaled his hidden crew to burst from the hold up the companionway. A confused hand-to-hand battle ensued in the tight confines of the *Jane*'s deck. The pirates were outnumbered but still fought ferociously. In an epic moment of the battle, Blackbeard and Maynard faced off against each other. Maynard fired a shot into Blackbeard's hulking body, which seemed to do little to slow the pirate down. Blackbeard swung his huge cutlass at Maynard, breaking the lieutenant's saber at the hilt. Maynard fell to the deck, and Blackbeard strode forward to deliver the final blow. As Blackbeard raised his sword over

Jean Leon Gerome Ferris's *The Capture of the Pirate, Blackbeard* depicts the battle between Blackbeard and Lieutenant Robert Maynard onboard the deck of the *Jane* at Ocracoke Inlet.

his head, a Scottish sailor approached from behind and buried his sword deep into Blackbeard's neck. The mighty Blackbeard collapsed to the deck. With a second blow, Blackbeard's head was severed from his body.

A post-battle autopsy found Blackbeard's body to have no fewer than five pistol shots and twenty severe cuts. Blackbeard's head was hung from the bowsprit of the *Adventure*, and the gruesome trophy was delivered to

Alexander Spotswood back in Virginia. The most infamous pirate in history had truly died a pirate's death.

Among the crowd watching Stede breathe his last at White Point was a young woman named Anne Cormac. Anne was born in Ireland, the product of an adulterous affair between her father, a lawyer named William, and a housemaid named Mary Brennan. Fleeing the scandal of his affair and illegitimate child, William sailed from Ireland to start a new life with Mary and Anne in Charleston. Though William first practiced law, he soon found his fortune in rice, purchasing a large plantation just outside Charleston.

Anne grew up a tomboy and was described as "a strapping, boisterous girl of a fierce and courageous temper." She was known to frequent the waterfront taverns of Charleston, drinking and carousing with the assorted sailors who shipped in and out of port. Unafraid to fight like a man, it was reported "that once, when a young fellow would have lain with her, against her will, she beat him so, that he lay ill of it a considerable time." Anne eventually fell in love with a sailor named James Bonny, and the two were married. Anne's father disapproved of the union. Convinced that Anne's new husband was angling to inherit his vast plantation, William Cormac "turned her [Anne] out of doors." Disappointed, the young couple sailed for Nassau in 1719.

In Nassau, Anne became acquainted with a former pirate named "Calico" Jack Rackham. Rackham had previously served as quartermaster under Charles Vane and had been onboard when Vane escaped from Woodes Rogers in Nassau Harbor the previous year. Rackham had also participated in Vane's plundering in Charleston and the beach party with Blackbeard at Ocracoke. When Blackbeard had refused to join forces with Vane, the pirates had sailed north to New York to prey on merchant ships. Returning south, a French man-of-war was spotted, but Vane decided, contrary to the opinion of Rackham and many of the crew, that the French prize was too dangerous to attack. Rackham called a vote of confidence of Vane, and he was unanimously deposed from his position as captain. Vane and fifteen men who remained loyal to him were placed in a small sloop that had been taken as a prize, and the company parted ways. Rackham was voted as captain and began plundering small vessels near Jamaica and the Bahamas. However, the decision was soon made by the crew to return to Nassau and apply for the king's pardon. Rackham told Governor Woodes Rogers that he had been forced into piracy by Charles Vane. Rogers, who despised Vane, granted Rackham and his men pardons.

Anne Bonny.

"Calico" Jack Rackham.

Anne and Rackham began a romance shortly after he received his pardon. But inspired by his new love, Rackham returned to his pirate lifestyle; this time, with Anne, dressed as a man, among his crew. Jealousy ran deep when Rackham noticed Anne spending time with another crew member named Mark Read. However, Anne revealed to Rackham that Mark Read

was actually "Mary" Read and, like Anne, had been posing as a man. The trio kept the strange secret from the rest of the crew, and pirate attacks commenced near Cuba and Jamaica. A ship was sent by the governor of Jamaica, commanded by Captain Barnet, to capture Rackham. Cornered at Negril, Rackham and all of the crew except Anne and Mary retreated below deck at the sight of the approaching Captain Barnet. Anne and Mary called for Rackham to "come up and fight like a man," but Rackham was resigned to his fate. At trial in November 1720, all of the pirates were found guilty and sentenced to hang, including Anne and Mary. However, both women "pleaded their bellies," meaning they were pregnant, and were spared the noose until their children were delivered. Anne was allowed to visit Rackham on the eve of his execution, where she told her lover, "If he had fought like a man, he need not have been hanged like a dog."

Rackham was hanged on November 18, 1720, and his body hung in chains at Port Royal's harbor entrance as a warning to others. Mary died of a fever while in prison, but Anne's story is lost to history. Legend holds that Anne's father learned of her imprisonment from the captain of a merchant vessel trading between Jamaica and Charleston, and Cormac paid off the governor of Jamaica to secure Anne's release.

Rackham's former captain, Charles Vane, was also running out of luck. After separating from Rackham, Vane had sailed south into the Bay of Honduras. Caught in a violent storm, Vane was shipwrecked on an uninhabited island. A ship eventually arrived, but unfortunately for Vane, it was commanded by an old acquaintance and former pirate named Captain Holford. Unwilling to take Vane onboard, Holford stated, "Charles, I shan't trust you aboard my ship, unless I carry you a prisoner; for I shall have you plotting with my men, knock me on the head and run away with my ship a pirating." Holford warned Vane that he would be returning to the island in a month's time, and if he found Vane still there, he would take him to Jamaica and hang him. Another ship rescued Vane before Holford returned, but while at sea, Vane's rescuers met with Holford's ship and invited Holford onboard for dinner. Holford saw Vane working on deck and reported to the captain that he was carrying one of the Caribbean's most wanted pirates. Vane was arrested and returned to Jamaica to stand trial. Found guilty and sentenced to hang on March 22, 1720, Vane would languish in jail for a year before finally being hanged on March 29, 1721. Like Rackham, his body was hung in gibbets at the harbor entrance of Port Royal.

George Lowther, who had attacked the *Amy* off Charleston and had killed the *Amy*'s captain, Gwatkins, from the beach at Sullivan's Island, was

The Pink House at 17 Chalmers Street is one of the oldest structures in Charleston (circa 1690). Legend holds that Anne Bonny's father owned and operated a tavern and boardinghouse here in the early eighteenth century. Anne may have returned to work here after her disappearance from Jamaica. Today, it is an art gallery (pinkhousegallery.tripod.com).

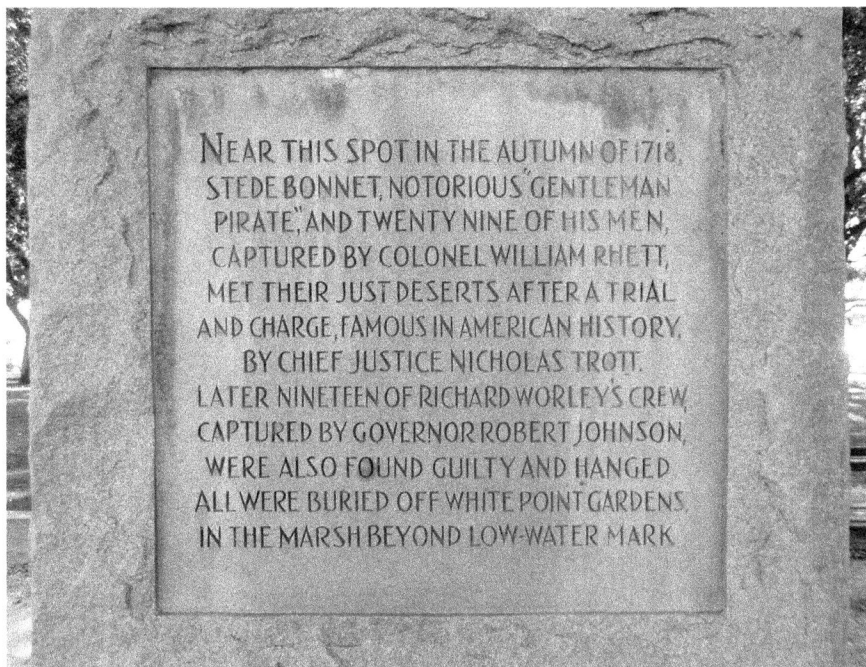

The pirate monument at the Battery in Charleston.

careening the *Revenge* at the remote island of Blanquilla in the southern Caribbean in late 1722. Surprised by the warship *Eagle*, commanded by Walter Moore, Lowther escaped through a window in his cabin into the dense vegetation of the island's interior. An intense search was made, and Lowther was eventually found on a beach on the opposite side of the island. He had died in the same manner as Captain Gwatkins—shot through the head. But Lowther's wound was self-inflicted, a spent pistol by his side.

Selected Bibliography

Alleyne, Warren. "A Barbadian Pirate." *Bajan* (June–August 1973).

Bostick, Douglas W. *The Morris Island Lighthouse*. Charleston, SC: The History Press, 2008.

Boston News Letter, 1719.

British Public Records Office. South Carolina Room, Charleston County Library, Main Branch. Charleston, SC.

British Vice-Admiralty Minute Books. Vol. II. Washington D.C.: National Archives and Records Service, 1981.

Burgess, Douglas R., Jr. *The Pirates' Pact: The Secret Alliance Between History's Most Notorious Buccaneers and Colonial America*. New York: McGraw Hill, 2009.

Butler, Lindley. *Pirates, Privateers and Rebel Raiders of the Carolina Coast*. Chapel Hill: University of North Carolina Press, 2000.

Charleston News and Courier, March 9, 1924; November 23, 1930; February 22, 1931; May 12, 1933.

Coker, P.C. *Charleston's Maritime Heritage, 1670–1865*. Charleston, SC: CokerCraft Press, 1987.

Cordingly, David. *Pirate Hunter of the Caribbean: The Adventurous Life of Captain Woodes Rogers*. New York: Random House, 2011.

———. *Under the Black Flag: The Romance and the Reality of Life Among the Pirates*. New York: Harcourt Brace & Company, 1995.

Duffus, Kevin P. *The Last Days of Black Beard the Pirate*. Raleigh, NC: Looking Glass Productions, 2008.

Earle, Peter. *The Pirates Wars*. New York: St. Martin's Press, 2003.

Ellms, Charles. *The Pirates' Own Book*. Philadelphia, PA, 1837.

Hogue, Lynn L. "Nicholas Trott: Man of Law and Letters." *South Carolina Historical Magazine* (1973).

Hughson, Shirley Carter. *The Carolina Pirates and Colonial Commerce, 1670–1740*. Baltimore, MD: Johns Hopkins Press, 1894.

Johnson, Captain Charles. *A General History of the Robberies & Murders of the Most Notorious Pirates*. New York: First Lyons Press, 1998.

Konstam, Angus. *Blackbeard: America's Most Notorious Pirate*. Hoboken, NJ: Wiley & Sons, 2006.

Lee, Robert E. *Blackbeard, the Pirate: A Reappraisal of His Life and Times*. Winston-Salem, NC: John F. Blair, 1974.

Leland, John G. *Stede Bonnet: Gentleman Pirate of the Carolina Coast*. Charleston, SC: Charleston Reproductions, 1972.

Little, Benerson. *The Sea Rover's Practice: Pirate Tactics and Techniques, 1630–1730*. Dulles, VA: Potomac Books, Inc., 2007.

The Mammoth Book of Pirates. Edited by Jon E. Lewis. Philadelphia: Running Press, 2007.

McCrady, Edward. *The History of South Carolina Under Proprietary Government, 1670–1719*. New York: Macmillan Company, 1897.

McIntosh, William. *Indians' Revenge: Including a History of the Yemassee Indian War*. Charleston, SC, 2009.

———. *Stede Bonnet's Trial*. Charleston, SC, n.d.

Morgan, Kenneth O. *The Oxford History of Britain*. New York: Oxford University Press, Inc., 2010.

Official Letters of Alexander Spotswood. Edited by R.A. Brock. Richmond, VA, 1885.

Porcher, Jennie Rose, and Anna Wells Rutledge. *The Silver of St. Philip's Church, 1670–1970*. Charleston, SC: St. Philip's Church, 1970.

Pre-Federal Admiralty Court Records, Province and State of South Carolina, 1716–1789. Vol. I. South Carolina Room, Charleston County Library Main Branch. Charleston, SC.

Proprietary Records of South Carolina. Vol. III. Edited by Susan Baldwin Bates and Harriott Cheves LeLand. Charleston, SC: The History Press, 2007.

Ramsay, David, MD. *South Carolina Heritage Series*. Vols. 3, 4. Newberry, SC: W.J. Duffie, 1858.

Rediker, Marcus. *Between the Devil and the Deep Blue Sea: Merchant Seamen, Pirates and the Anglo-American Maritime World, 1700–1750*. Cambridge, UK, 1987.

Schomette, Donald G. *Pirates on the Chesapeake*. Centreville, MD: Tidewater Publishers, 1985.

South Carolina Department of Archives and History. 8301 Parklane Road, Columbia, SC.

Stevenson, Robert Louis. *Treasure Island*. London, 1883.

Strangward, Ethel Partridge. *Nathaniel Partridge of Charles Town, South Carolina and His Descendants*. DeLeon Springs, FL: E.O. Painter Printing, Co., 1985.

The Tryals of Major Stede Bonnet and Other Pirates. London, 1719.

Weir, Robert M. *Colonial South Carolina: A History*. Columbia: University of South Carolina Press, 1997.

Whipple, Addison B.C. *Pirates Rascals of the Spanish Main*. New York: Doubleday & Company, 1957.

Williams, Lloyd Hanes. *Pirates of Colonial Virginia*. Richmond, VA, 1937.

Woodard, Colin. *The Republic of Pirates*. Orlando, FL: Harcourt, Inc., 2007.

Index

About the Author

Christopher Byrd Downey (Captain Byrd) received his degree in history from Virginia Tech in 1995. He has worked in the maritime industry for over fifteen years. A resident of Charleston since 2001, he has also authored *Stede Bonnet: Charleston's Gentleman Pirate* (The History Press, 2012). A U.S. Coast Guard licensed captain, Captain Byrd offers pirate boat tours of Charleston Harbor, as well as bicycle tours along the quiet, scenic backroads of the Lowcountry. Visit him at www.captainbyrds.com.

Visit us at
www.historypress.net
..
This title is also available as an e-book